THE GREAT WESTERN R.

— VOLUME 4 —

NORTH & WEST ROUTE

Stanley C. Jenkins & Martin Loader

AMBERLEY

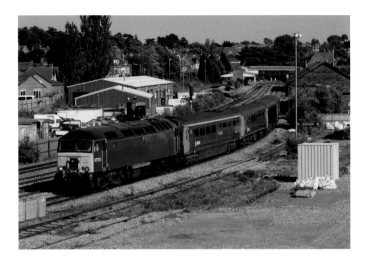

Passing Hereford

Class '57' locomotive No. 57313 runs non-stop through Hereford station with the 4.15 p.m. Cardiff Central to Holyhead service on 2 June 2009.

ACKNOWLEDGEMENTS

Thanks are due to Mike Marr for the use of the photographs on page 50. Other images were obtained from the Lens of Sutton Collection, and from the authors' own collections. Thanks are also due to Chris Turner for the loan of GWR timetables and other contemporary documents.

A Note on Closure Dates

British Railways closure announcements referred to the first day upon which services would no longer run, which would normally have been a Monday. However, the final day of operation would usually have been the preceding Sunday (or, if there was no Sunday service, the preceding Saturday). In other words, closure would take place *on a* Saturday or Sunday, whereas the 'official' closure world take place *with effect from* the following Monday.

First published 2015

Amberley Publishing
The Hill, Stroud, Gloucestershire, GL5 4EP
www.amberley-books.com

Copyright © Stanley C. Jenkins & Martin Loader, 2015

The right of Stanley C. Jenkins & Martin Loader to be identified as the Authors of this work has been asserted in accordance with the Copyrights, Designs and Patents Act 1988.

ISBN 978 1 4456 4129 4 (print)
ISBN 978 1 4456 4141 6 (ebook)

British Library Cataloguing in Publication Data.
A catalogue record for this book is available from the British Library.

Typesetting by Amberley Publishing.
Printed in Great Britain.

INTRODUCTION

The 'North & West Route', which, in recent years, has become known as the 'Welsh Marches Line', extends from Newport to Chester. Historically, this 137-mile route is an amalgam of three distinct railways: the Shrewsbury & Chester Railway, The Shrewsbury & Hereford Railway and the Newport, Abergavenny & Hereford Railway. All three lines came under Great Western control at a relatively early date, although the Shrewsbury & Hereford section became a joint undertaking, which was owned by the GWR and the London & North Western Railway.

THE SHREWSBURY & CHESTER RAILWAY

The Shrewsbury & Chester Railway (S&CR) originated during the Railway Mania years of the 1840s, at a time when ambitious entrepreneurs were promoting a multiplicity of lines in all parts of the British Isles. One of the more successful schemes floated at that time was the North Wales Mineral Railway, which sought powers for the construction of a line between Chester and the Wrexham and Ruabon coalfields. The North Wales Mineral Railway obtained its Act of Incorporation on 6 August 1844, and the promoters were thereby empowered to begin construction of a railway between Chester and Wrexham.

In the following year, a group of North Wales Mineral Railway supporters, led by Robert Roy (1795–1875) of Brymbo Hall and J. B. Ross of Chester, promoted the Shrewsbury, Oswestry & Chester Junction Railway, with the aim of extending the North Wales Mineral line southwards to Shrewsbury in opposition to a rival scheme that was backed by the Chester & Holyhead Railway. Having passed successfully through Parliament, the Shrewsbury, Oswestry & Chester Junction Bill

received the royal assent on 30 June 1845, and in 1846 the Shrewsbury, Oswestry & Chester Junction Railway joined forces with the parent North Wales Mineral Co. to form the Shrewsbury & Chester Railway.

Meanwhile, construction was rapidly proceeding on the northern section of the Shrewsbury & Chester route, and on 4 November 1846 the railway was opened between Saltney Junction (Chester) and Ruabon, a distance of 15 miles 18 chains. The new line did not reach Chester itself, but Shrewsbury & Chester trains were able to enter Chester station by means of running powers over the Chester & Holyhead line. At the southern end, work continued on the Shrewsbury, Oswestry & Chester Junction section, and on 14 October 1848 the line was ceremonially opened between Ruabon and Shrewsbury, a distance of 25 miles 23 chains.

There was, as yet, no direct rail link to Oswestry, although local residents and traders were able to travel by road to the Shrewsbury & Chester station at Gobowen, some 2 miles to the north-east of their town. However, on 23 December 1848, a 2 mile 31 chain branch was ceremonially opened, and regular public services commenced running between Oswestry and Gobowen on 1 January 1849. The S&CR was, at this time, still an independent concern, but in 1851 the shareholders decided that their undertaking would be amalgamated with the Great Western Railway and, the necessary Act of Parliament having been obtained, the amalgamation came into force on 1 September 1854.

THE SHREWSBURY & HEREFORD RAILWAY

The Shrewsbury & Chester Railway had been promoted by a small group of landowners and industrialists with interests in the Welsh border areas.

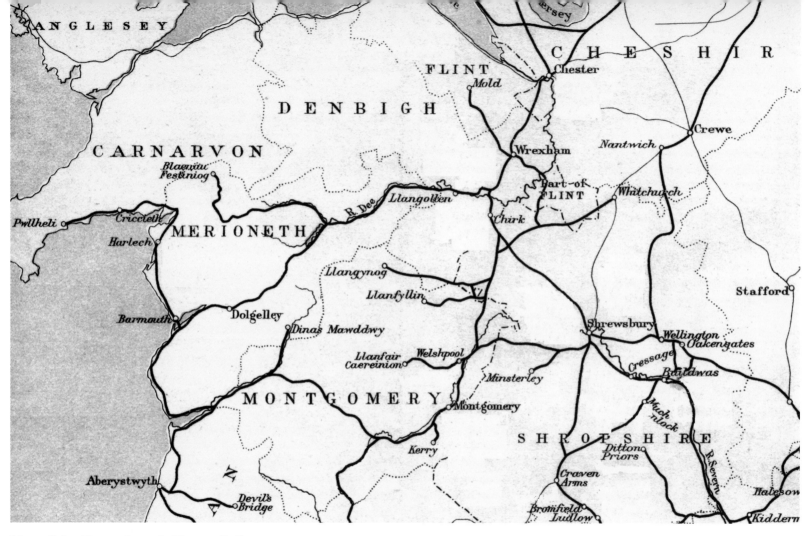

Map of the Shrewsbury & Chester Railway

A map of the Great Western system in Shropshire and the northern Welsh borders. The Shrewsbury & Chester line runs southwards via Wrexham and Chirk, and the North & West route then continues south-south-westwards through Craven Arms and Ludlow.

Their activities were initially centred on the northern border district around Wrexham, but having obtained Parliamentary consent for a line from Chester to Shrewsbury, the same group of promoters formed the Shrewsbury & Hereford Railway (S&HR) with the aim of providing a southwards link towards the South Wales industrial areas. The Shrewsbury & Hereford company was incorporated by Act of Parliament on 3 August 1846 (9 & 10 Vic.cap.325), with powers for the construction of 51-mile line commencing at Hereford by a junction with the Newport, Abergavenny & Hereford Railway and terminating at Shrewsbury. To pay for their scheme, the promoters were authorised to raise £800,000 in £10 shares.

Having obtained their Act of Incorporation, the supporters of the Shrewsbury & Hereford scheme were eager to begin construction of their line, but external events intervened before the project could be brought to a successful conclusion. A series of harvest failures resulted in a severe financial crisis which brought the Railway Mania to an abrupt end. Railway companies were unable to raise their authorised capital, and in these melancholy circumstances the Shrewsbury & Hereford promoters were unable to implement their scheme.

At length, improved trading conditions enabled the S&HR project to regain momentum, and towards the end of 1849 a contract for construction of the Shrewsbury & Hereford Railway was awarded to Thomas Brassey (1805–70), the great Victorian contractor. Mr Brassey suggested that he might work the line at his own risk, paying 3½ per cent on the cost. The S&HR directors were happy to accept these terms, and in an atmosphere of renewed optimism, the work of construction was pressed forward without further delay.

In engineering terms the route presented many problems. From Hereford, the authorised line pursued a northerly course through the Welsh borders along the valleys of the rivers Lugg, Teme, Onny and Cound Brook. A tunnel would be necessary at Dinmore, and the route would incorporate gradients of 1 in 90 and 1 in 100 on the long climb to Church Stretton, where the railway would reach its summit, some 400 feet above mean sea level.

The line was engineered by Henry Robertson (1814–88), who, like Thomas Brassey, was an important figure during the great days of Victorian railway construction. Born in Scotland, Henry Robertson started his career as an engineer, and by the 1850s he was acting in that capacity for several companies, including the Shrewsbury & Chester, Shrewsbury & Hereford and Shrewsbury & Birmingham railways. Having prospered tremendously during the Railway Mania, he was also involved in mining and engineering, having acquired substantial interests in the Brymbo and Westminster collieries, and the Ruabon Coal Co. He was also one of the founders of Messrs Beyer, Peacock & Co., the famous Manchester-based locomotive building firm.

Construction continued apace on the Shrewsbury & Hereford line, and the first section was ready for opening on 21 April 1852, when trains began running between Shrewsbury and Ludlow, a distance of 27 miles 43 chains. Further progress was impeded, albeit briefly, by the need to construct a 1,096-yard tunnel and associated earthworks at Dinmore, to the north of Hereford. This task was more difficult than the engineer had anticipated, the geological strata in the immediate vicinity being very uncertain. It was therefore decided that the tunnel would be constructed in the first instance as a single-line bore, which would be duplicated if and when traffic requirements required.

Thereafter, rapid progress was made, and the first goods trains were able to run between Shrewsbury and Hereford on 30 July 1852. Finally, on 6 December 1853, the railway was opened throughout its length for the carriage of passengers between Shrewsbury and a terminal station at Hereford Barr's Court, on the eastern side of

the city. Dinmore Tunnel was the principal engineering feature, but elsewhere there were numerous over or underbridges, while for much of its length the new line was carried on lofty embankments or in deep cuttings, the formation being wide enough to accommodate a second line of rails. The new line was initially worked by the Shrewsbury & Chester Railway, but Thomas Brassey's lease soon came into effect, and it was then agreed that the contractor would work the line for a period of eight years, commencing on 1 July 1854.

In the meantime, the S&HR directors had taken steps to place their undertaking in a better financial condition, and in 1854 they obtained a new Act permitting a reduction of the original share capital and a reduction of the share price from £20 to £10 per share. This was followed, on 23 June 1856, by a new Act enabling the S&HR to raise an additional £225,000 by the creation of 5 per cent preference shares, together with a further £75,000 by loans.

The Shrewsbury & Hereford Railway settled down to enjoy a life of modest prosperity. The S&HR was an independent concern, but it was somewhat uncomfortably situated in an area dominated by inter-company rivalries. In particular, the Great Western Railway was engaged in a bitter feud with the rival London & North Western Railway, with both companies keen to consolidate their respective positions in the Welsh borders. Matters came to a head in 1862, in which year Thomas Brassey's eight-year lease of the Shrewsbury & Hereford Railway came to an end.

After much behind-the-scenes activity, it was eventually agreed that the S&HR line would be leased jointly to the GWR and L&NWR companies under the provisions of an Act of Parliament (25 & 26 vic.cap.198) obtained on 29 July 1862. The Act provided that the Shrewsbury & Hereford Railway would be placed under the control of a joint committee of eight members, four of whom would be nominated by the GWR, while the other four would represent the London &

North Western Railway. Meanwhile, the gap in communication between Hereford and Newport had been filled by another, entirely separate company known as 'The Newport, Abergavenny & Hereford Railway'.

THE NEWPORT, ABERGAVENNY & HEREFORD RAILWAY

The Newport, Abergavenny & Hereford Railway (NA&HR) was incorporated by Act of Parliament on 3 August 1846, with powers for the construction of a railway commencing 'by a junction with the intended Newport & Pontypool Railway in the Parish of Llanvrechva in the County of Monmouth' and terminating beside 'the Widemarsh Turnpike in the Parish of St John the Baptist in the City of Hereford'. The authorised capital of the new company was £733,000, and the proposed route would incorporate the trackbeds of the earlier Llanvihangel, Grosmont and Hereford railways, all three lines being simple tramways of the most primitive type.

At first, the Newport, Abergavenny & Hereford scheme made little progress, as the project had been severely hindered by the economic crisis that had developed during the later 1840s. Eventually, with help from the London & North Western Railway, the NA&HR promoters were able to implement their scheme, and the works were well underway by 1852, the engineer being Charles Liddell (1815–94). The NA&HR line was ceremonially opened on 6 December 1853. Public services began on 2 January 1854 and Newport (Mill Street) station was reached by means of through running arrangements over the Newport to Pontypool line of the Monmouthshire Railway & Canal Co.

At its northern end, the railway terminated at a separate NA&HR station known as Hereford (Barton), although an extension continued northwards for a distance of about 1 mile to reach the Shrewsbury & Hereford line at 'Barr's Court Junction'. In the meantime, the Newport, Abergavenny & Hereford directors had obtained powers

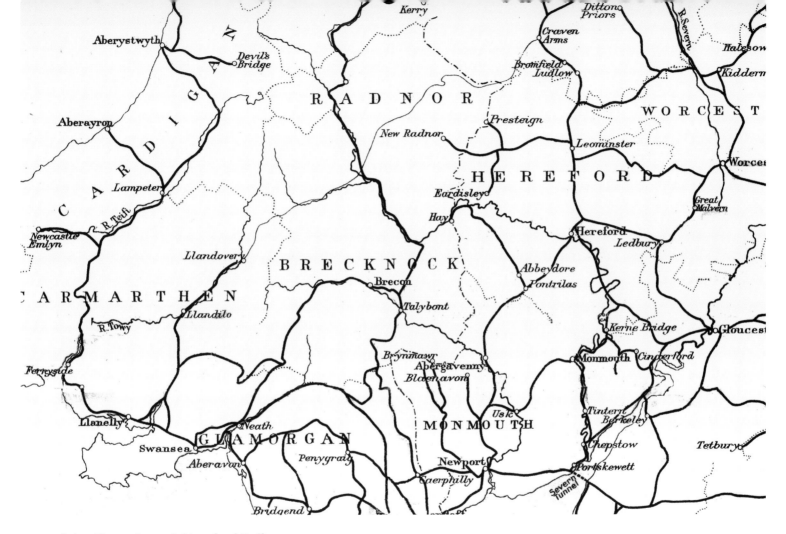

Map of the Shrewsbury & Hereford Railway

A map of the Great Western system in Herefordshire and the southern Welsh borders. The Shrewsbury & Hereford line forms a southwards continuation of the North & West route via Craven Arms, Ludlow and Hereford, while the Newport, Abergavenny & Hereford line extends south-westwards to Abergavenny before turning southwards for the final section towards Newport.

for an extension running westwards from the NA&AR main line at Pontypool Road to a junction with the Taff Vale Railway at Quakers Yard. The total length of the NA&HR was 40 miles and, when it was completed in 1858, the heavily engineered Taff Vale Extension added another 12 miles to this total, bringing the total route mileage of the Newport, Abergavenny & Hereford system to 52 miles 6 chains.

The Newport, Abergavenny & Hereford Railway was initially worked by the L&NWR, but its operating agreement with the North Western was terminated following a disagreement about through traffic rates. Having broken away from its former allegiance, the NA&HR had to find a new eastern outlet for its South Wales coal traffic, and the Abergavenny company therefore joined forces with the Oxford, Worcester & Wolverhampton Railway (OW&WR) in order to complete the Worcester & Hereford Railway. The latter company had been authorised in 1853 as a link between Worcester, Great Malvern and Hereford, but little progress was made until 1856, when the NA&HR injected money and new life into the scheme.

Although the Newport, Abergavenny & Hereford Railway was prepared to support the Worcester & Hereford scheme, the Abergavenny company was a struggling local railway with few capital resources. The Oxford, Worcester & Wolverhampton Railway, on the other hand, was a comparatively wealthy concern, and the new partnership between the NA&HR and OW&WR companies was in effect an Oxford, Worcester & Wolverhampton takeover. It was agreed that the two railways would be merged into a new undertaking, to be known as 'The West Midland Railway', which would also include the Worcester & Hereford Railway, and these arrangements were formalised by the provisions of an Act of Parliament obtained on 1 July 1860.

By this Act, the Newport, Abergavenny & Hereford and the Worcester & Hereford railway companies were dissolved and merged with the Oxford, Worcester & Wolverhampton Railway under its new name. Sixteen OW&WR directors were joined by five from the NA&HR and two from the W&HR to form an enlarged board, based at Worcester. The then Chairman of the OW&WR, William Fenton, became Chairman of the West Midland Railway, while W. P. Price, the former Chairman of the Newport, Abergavenny & Hereford Railway, became Deputy Chairman of the West Midland Railway.

The Worcester & Hereford line was opened between Henwick and Malvern Link on 25 July 1859 and, on 25 May 1860, the route was extended to Malvern Wells. Finally, on 13 September 1861, the W&HR line was opened throughout between Worcester, Great Malvern and Hereford. In the interim, it was announced that the West Midland Railway had decided to lease itself to the Great Western company while, in return, the WMR would be granted running powers over the GWR system. Two years later, in 1863, the Great Western and West Midland companies were fully and finally amalgamated, and the GWR thereby obtained control of a lengthy north-to-south route along the Welsh borders between Newport, Hereford, Shrewsbury and Chester.

SUBSEQUENT DEVELOPMENTS

When first opened, the Newport, Abergavenny & Hereford route had joined the 'Eastern Valleys' line of the Monmouthshire Railway & Canal Co. at Coed-y-Gric Junction, the Monmouthshire line being used as means of access to Newport. In 1874, however, the opening of the Pontypool, Caerleon & Newport Railway provided an alternative route between Pontypool Road and Newport (Maindee Junction), and, following this development, four long-distance trains per day were introduced between Cardiff, Pontypool Road, Hereford and the North of England.

There had, meanwhile, been important developments at Hereford; a further line, known as the Hereford, Ross & Gloucester Railway

had been completed throughout between Grange Court Junction and Hereford Barr's Court on 1 June 1855. The Hereford, Ross & Gloucester line was originally a 7-foot 'broad gauge' route, but in 1862 the railway was amalgamated with the GWR, and just six years later it was decided that the HR&GR line would be converted from broad to standard gauge. There were, however, problems at Hereford, where the physical connections between the Shrewsbury & Hereford and Newport, Abergavenny & Hereford systems had dictated the pattern of train services that could be provided.

Barr's Court Junction was orientated towards Shrewsbury, and this meant that trains proceeding between Barr's Court and Barton stations were faced with an intermediate reversal at the point of convergence between the S&HR and NA&HR lines. Shrewsbury & Hereford services were able to run into either Barr's Court or Barton stations, but trains to or from South Wales could only use the NA&JR station at Barton, while this station was also used by trains on the Worcester & Hereford route when that line was completed on 1861. Local travellers and businessmen were extremely dissatisfied with these arrangements, and there were repeated demands that a common station should be provided so that goods and passengers could be rapidly and efficiently transferred between the different railway companies.

To obviate these difficulties, the Great Western and North Western companies decided that a circuitous connecting loop would be constructed between the Newport, Abergavenny & Hereford line at Red Hill and the Hereford, Ross & Gloucester route at Rotherwas. The proposed loop line, which would pass well to the south of Hereford, would enable traffic to and from South Wales to be routed into Hereford Barr's Court, which would thereby become the most important station in the city.

The GWR and L&NWR companies signed an agreement on 1 June 1864 whereby the North Western agreed to seek Parliamentary consent for the 'Hereford Curve' and the Great Western promised to support the necessary bill in its passage through Parliament. Having obtained Parliamentary sanction, the North Western would construct the new connecting line as a double-track, standard gauge line, while the Great Western would install mixed gauge trackwork on the northernmost section of the Hereford, Ross & Gloucester route between Rotherwas Junction and Hereford Barr's Court station.

When the Hereford Loop was completed, both companies would exercise running powers over the lines between Barr's Court Junction, Barr's Court station, Rotherwas Junction and Red Hill Junction, while the L&NWR would pay the sum of £3,000 to the Great Western as a reimbursement for costs incurred. Moreover, it was also agreed that maintenance and other expenses at Barr's Court would be shared between the GWR and L&NWR companies. After an easy passage through Parliament, the scheme received the royal assent on 2 August 1865 and construction of the new connecting line began during the early months of the following year, the contractor being Thomas Brassey.

On 28 July, a notice placed in *The Hereford Journal* announced that the loop line would be opened for passenger traffic on 1 August 1866, on which day most of the trains from Shrewsbury, Newport and Worcester were diverted into Hereford Barr's Court station. The loop line diverged south-westwards from the HR&GR route at Rotherwas and then ran west-south-westwards for a distance of approximately 2 miles. The new line ran on embankments for much of its length, and there were several road underbridges and one road overbridge, together with a deep cutting on the approaches to Red Hill Junction. There were no special celebrations to mark the first day of operation, although the opening of the Hereford Curve was, in retrospect, an event of considerable significance, insofar as it underlined the importance of Barr's Court as Hereford's main passenger station.

RAILWAY TIME TABLES, ETC.

On and after June 1st, 1850.

SHREWSBURY AND CHESTER RAILWAY.

LEAVE	I. 1,2,3 Cla.	II. 1 & 2 Cla.	III. 1 & 2 Cla.	IV. 1 & 2 Cla.	V. 1 & 2 Exp.	VI. 1,2,3 Cla.	VII.	SUN. TRNS. I. 1,2,3 Cla.	SUN. TRNS. II. 1,2,3 Cla.
	A.M.	A.M.	A.M.	P.M.	P.M.	P.M.		A.M.	P.M.
CHESTER	3 50	8 0	10 45	1 40	4 20	7 30		10 10	6 15
Saltney		8 5	10 51	1 46		7 37		10 16	6 21
Pulford		8 13	10 57	1 55		7 46		10 27	6 32
Rossett		8 18	11 4	2 0	4 36	7 52		10 30	6 37
Gresford		8 26	11 19	2 6	4 40	8 0		10 39	6 44
WREXHAM	4 51	8 34	11 17	2 15	4 49	8 10		10 48	6 53
Rhos		8 42	11 21	2 23		8 18		10 56	7 1
RUABON	5 17	8 47	11 28	2 28	5 0	8 25		11 3	7 8
Cefn	5 29	8 52	11 33	2 33		8 31		11 9	7 14
Llangollen Road (1)	5 39	8 57	11 37	2 37	5 8	8 36		11 15	7 20
CHIRK		9 2	11 43	2 41	5 13	8 40		11 21	7 26
Preesgwyn		9 7	11 48	2 46		8 44		11 26	7 31
Gobowen (2)	6 6	9 15	11 54	2 55	5 22	8 54		11 32	7 37
OSWESTRY arr.		9 35	12 4	3 15	5 35	9 10		11 47	7 52
OSWESTRY lve.		9 0	11 44	2 45	5 10	8 30		11 17	7 22
Whittington (3)	6 19	9 20	12 0	3 0	5 27	9 1		11 39	7 44
Rednal (4)	6 36	9 26	12 6	3 6		9 8		11 48	7 53
Baschurch (5)	7 0	9 40	12 23	3 20	5 45	9 17		11 59	8 3
Leaton	7 20	9 49	12 35	3 30		9 30		12 10	8 15
SHREWSBURY	7 45	10 0	12 50	3 40	5 59	9 40		12 20	8 25

LEAVE	1,2,3 Cla.	1 & 2 Cla.	1 & 2 Cla.	1 & 2 Cla.	1 & 2 Cla.	1,2,3 Cla.		1,2,3 Cla.	1,2,3 Cla.
	A.M.	A.M.	A.M.	P.M.	P.M.	P.M.		A.M.	P.M.
SHREWSBURY	3 30	7 15	9 45	12 10	4 0	6 30		8 50	6 40
Leaton			9 55			6 41		9 0	6 45
Baschurch (5)	4 0	7 29	10 4	12 28	4 18	6 54		9 10	6 55
Rednal (4)	4 20	7 41	10 15		4 31	7 2		9 24	7 9
Whittington (3)	4 34	7 48	10 22	12 46	4 38	7 9		9 33	7 20
OSWESTRY arr.		8 5	10 40	1 2	4 55	7 45		9 55	7 40
OSWESTRY lve.		7 30	10 13	12 38	4 35	7 5		9 25	7 10
Gobowen (2)	4 43	7 53	10 28	12 50	4 43	7 16		9 40	7 25
Preesgwyn			10 34			7 26		9 46	7 31
CHIRK		8 1	10 37	12 56	4 48	7 30		9 51	7 36
Llangollen Road (1)	5 3	8 6	10 43	1 1	4 53	7 35		9 57	7 42
Cefn			10 47			7 40		10 2	7 47
RUABON	5 18	8 13	10 52	1 9	5 0	7 46		10 9	7 54
Rhos			10 57			7 53		10 15	8 0
WREXHAM	5 34	8 24	11 5	1 21	5 12	8 1		10 24	8 9
Gresford		8 33	11 12	1 30	5 20	8 10		10 33	8 18
Rossett		8 39	11 18	1 36	5 25	8 15		10 39	8 24
Pulford			11 23			8 24		10 45	8 30
Saltney	6 37	8 49	11 31		5 36	8 31		10 55	8 40
CHESTER	6 50	8 55	11 40	1 55	5 45	8 40		11 0	8 50

1. Station for Llangollen, Corwen, &c. 2. Station for St. Martins and Selattyn. 3. Station for Ellesmere. 4. Station for West Felton, Knockin and Kinnerley. 5. Station for Wem.

EXTRA TRAIN.—A Train will leave Oswestry Station on the morning of every Shrewsbury fortnightly cattle market, at 5 o'clock a.m., for the conveyance of cattle as well as passengers.

MARKET TICKETS are issued on market and fair days to Chester, Salop, Oswestry, or Wrexham, as the case may be, from the Stations near the market towns—Fare, 1d. per mile each way.

RAILWAY FARES FROM OSWESTRY.—To Shrewsbury. 1st Class, 4s. 2d. 2nd Class, 3s. 3rd Class, 1s. 6d.—Day Tickets. 1st Class, 6s. 3d. 2nd Class, 4s. 6d.

To Chester. 1st Class, 6s. 0d. 2nd Class, 4s. 4d. 3rd Class, 2s. 2½d.—Day Tickets. 1st Class, 9s. 0d. 2nd Class, 6s. 0d.

Parcels under 28lbs. from Chester to Oswestry, are charged 9d.; under 56lbs. 1s., and under 112lbs. 1s. 3d. From Shrewsbury to Oswestry, under 28lbs. 6d., under 56lbs. 9d., and under 112lbs. 1s.

Day Tickets issued on Saturday to return on the Sunday or Monday following.

Parties taking Day Tickets, and getting out of the Train at any other Station than those mentioned on the Ticket, will not be allowed to go on by another Train without re-booking.

Season Tickets are issued by this Company at the following rates per mile, viz.:— First Class, twelve months, 20s.; six months, 12s.; three months, 8s. Second Class, twelve months, 15s.; six months, 9s.; three months, 6s. Any fractional part of a mile will be charged the same as a whole mile.

CHILDREN'S FARES.—By 1st and 2nd Class, Children under Ten years of age are charged half-fare;—in arms, free. By 3rd Class, Children above 3 and under 12, half-fare;—under 3, free.

OSWESTRY BRANCH RAILWAY.

Mr. EDWIN JONES, Station Master and Goods Agent.

LEAVE	I. 1 & 2 Cla.	II. 1 & 2 Cla.	III. 1 & 2 Cla.	IV. 1 & 2 Cla.	V. 1 & 2 Cla.	VI. 1 & 2 Cla.	VII. 1 & 2 Cla.	VIII. 1 & 2 Exp.	IX. 1 & 2 Exp.	X. 1,2,3 Cla.
	A.M.	A.M.	A.M.	A.M.	P.M.	P.M.	P.M.	P.M.	P.M.	P.M.
Oswestry	7 30	9 0	10 13	11 44	12 38	2 45	4 35	5 10	7 5	8 30
Gobowen	7 53	9 15	10 28	11 54	12 50	2 55	4 43	5 22	7 16	8 54
Shrewsbury ar.		10 0		12 50		3 40		5 59		9 40
Chester, ar. at	8 55		11 40		1 55		5 45		8 40	
Shrewsbury	7 15		9 45		12 10		4 0		1,2,3 6 30	
Chester		8 0		10 45		1 40		4 20	7 30	
Gobowen	7 53	9 15	10 28	11 54	12 50	2 55	4 43	5 22	8 54	7 16
Oswestry, ar. at	8 5	9 35	10 40	12 4	1 2	3 15	4 55	5 35	9 10	7 45

TRAINS ON CONNECTED LINES.

London, Birmingham, Manchester, Liverpool, Holyhead, &c.	I. select 1 & 2	II. mix'd 1,2,3	III. select 1 & 2	IV. select 1 & 2	V. select 1 & 2	VI. mix'd 1,2,3	SUNDAY TRAINS. mix'd 1,2,3	SUNDAY TRAINS. mix'd 1,2,3	SUNDAY TRAINS. mix'd 1,2,3
Shrewsbury		10 0	12 50	3 40	5 59			8 25	
Wolverhampton		11 30	2 10	5 5	7 10			9 50	
Birmingham		12 45	3 0		7 58				
London		7 0			11 10				
London				10 0					
Birmingham				1 40					
Wolverhampton		6 0	8 10	10 15	2 40	5 5	7 30	5 15	
Shrewsbury		7 15	9 45	12 10	4 0	6 30	8 50	6 40	
Chester	7 0	9 0	12 0	2 0	6 0	9 0		8 45	
Birkenhead	8 0	9 30	12 45	2 45	6 45	9 45		9 30	
Liverpool	8 15	9 45	1 5	3 5	7 5	10 5		9 50	
Manchester	9 55	12 30	4 5	5 30	9 15				
Manchester		7 20	10 15	12 30	3 0		6 45		
Liverpool		9 8	11 40	2 20	4 30		8 0		
Birkenhead	7 0	10 0	12 30	3 30	6 30		9 15	1 45	
Chester	7 45	10 30	1 15	4 15	7 15		10 0	2 30	
Chester	8 0	10 35		1 45	6 30	10 25	4 30	10 25	
Bangor	12 15	12 55		4 5	9 30	12 10	7 30	12 10	
Holyhead								1 30	
Holyhead				2 0					
Bangor		6 0	8 30	3 20			6 0	5 30	
Chester		10 15	1 0	5 0			9 15	8 30	
Chester		10 45	3 0		4 40				
Mold		11 25	3 45		5 20				
Mold		9 40	12 30	4 0	8 30	3 20			
Chester		10 20	1 10	4 40	9 10	4 0			

The Publisher cannot guarantee the accuracy of this table, not being in direct communication with any Company except the Shrewsbury and Chester. To the courtesy of the Secretary of that Company he is indebted for the whole of the Railway information.

A Shrewsbury & Chester Timetable of 1850

This early timetable, dated 1 June 1850, shows six trains each way between Shrewsbury, Gobowen, Wrexham and Chester, the usual journey time being around 2 hours in each direction. All trains carried both first- and second-class travellers, but there were, in addition, two up and two down 'Parliamentary' services, which also catered for third-class passengers at the statutory rate of 1d per mile.

Newport High Street

Present-day 'North & West' services commence their journeys at Carmarthen, Milford Haven or other stations in South Wales, and then run eastwards along the South Wales main line to Newport, where they diverge northwards onto the Pontypool, Caerleon & Newport line. Known for many years as Newport High Street, Newport station was opened by the South Wales Railway on 18 June 1850. The station was much enlarged during the 1870s, and in its rebuilt form Newport High Street incorporated lengthy up and down platforms for main line traffic, and an additional through platform on the up side. The up platform was an island with tracks on either side. Four tracks were provided between the up and down platforms, and these were equipped with scissors crossovers so that each platform could accommodate two trains. There was a bay platform at the west end of the main down platforms, and an additional platform was subsequently added for local 'Valleys' traffic on the up side.

A further programme of improvements was carried out by the Great Western over a seven-year period, finishing in 1930. A modern power signal box with 96 levers was brought into use on 29 May 1927 when a new Newport East Box replaced Newport East and Maindee West boxes, and in the following year a similar installation with 125 levers was opened at Newport West. Other improvements included platform extensions and the provision of an impressive five-storey station building on the down side. This new structure was in the neo-classical style, its appearance being described as 'magnificent' by *The Great Western Railway Magazine*. The upper picture is looking eastwards along the island platform during the 1920s; Newport Middle Box, which can be seen to the left, was closed in 1928. The lower view shows the main façade of the down side station building.

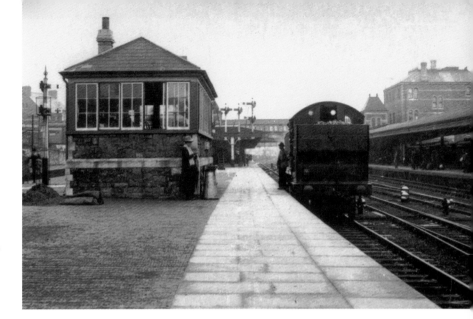

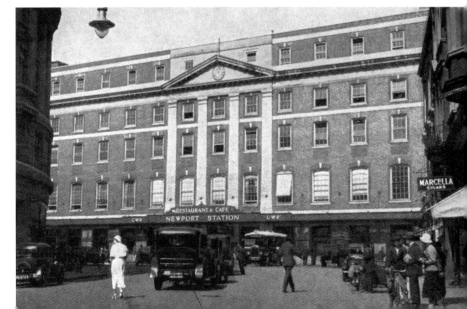

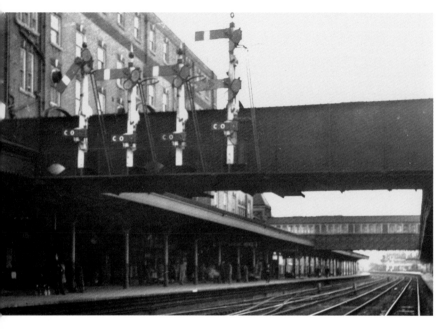

Right: **Newport – Hillfield Tunnel**

Trains approaching Newport High Street from the west pass through the 180-yard Hillfield Tunnel. The photograph, taken on 11 September 1997, shows class '37' locomotive No. 37902 emerging from the western portal of the tunnel at the head of the 10.05 a.m. Llanwern to Cardiff Tidal oil empties, while sister locomotives Nos 37670 and 37696 wait at the signal to gain entry to the nearby Alexandra Dock Yard with the 4.56 a.m. 'Enterprise' freight service from St Blazey. The tunnel was doubled in 1912, when the Great Western constructed a new double-track tunnel beside the original bore.

Left: **Newport High Street**

This photograph of the main down platform was probably taken during the 1950s. It shows the north side of the main station building, together with an array of Great Western lower quadrant semaphore signals, each of the red 'stop' signals being equipped with subsidiary 'calling-on' arms that permitted trains to enter, at caution, a section of line that was already occupied by another train. In steam days, the platforms were numbered from 1 to 8, platforms 1 and 2 being the Down Main platform, while platform 3 was the Down Bay. Platforms 4–5 and 6–7 were the two sides of the island platform, and platform 8 was the 'Valleys' platform on the north side of the station. In its present-day form, the station has four through platforms, and these are now numbered from 1 to 4.

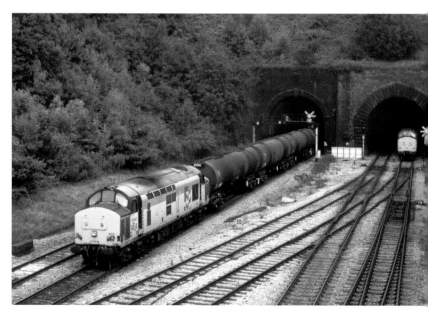

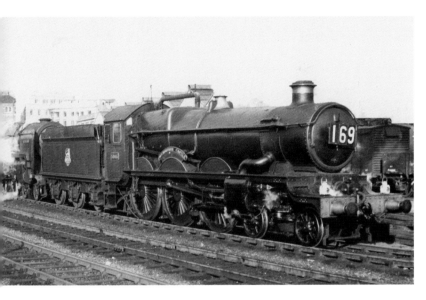

Left: **Newport High Street**

'Castle' class 4-6-0 No. 5005 *Manorbier Castle* pilots an unidentified 'Britannia' class 4-6-2 at Newport during the 1950s. The 'Castles' were introduced in 1923, and they soon appeared in South Wales, twelve of these engines being allocated to Cardiff Canton shed by 1938, while a further eleven were stationed at Landore. They were initially employed mainly on Paddington services, but they also appeared on the North & West route, hauling the principal express services between Cardiff and Shrewsbury.

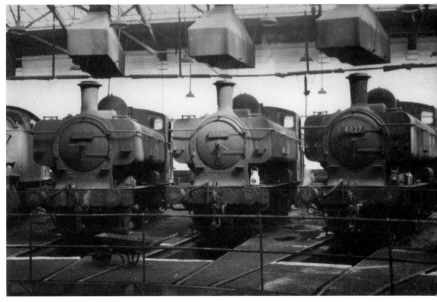

Right: **Newport – Pannier Tanks in Ebbw Junction Shed**

Newport was the site of Ebbw Junction shed – an important motive power depot and the largest GWR shed in South Wales. This major facility was sited to the west of Hillfield Tunnel, the shed building being a large 'roundhouse' structure containing two turntables. There were, in addition, a number of other facilities, including offices, stores, workshops and a coaling plant. The main shed was a substantial, brick-built structure measuring approximately 363 feet by 245 feet at ground level, while the adjacent repair shop measured 197 feet by 112 feet. In later years, the usual allocation was around 145 locomotives, including large 4-6-0s for main line services, and various 2-8-0, 2-6-0, 2-6-2T and 0-6-0 classes for goods services and local passenger work. The photograph shows the interior of one of the sheds circa 1962, with '57XX' class 0-6-0PTs Nos 4627, 4643 and 8705 clustered around one of the turntables.

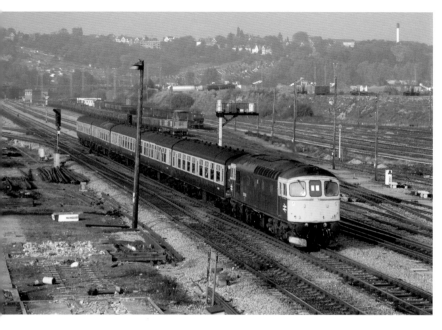

Left: **Newport – Ebbw Junction**

Class '33' locomotive No. 30032 passes Ebbw Junction, Newport with the 12.10 a.m. Portsmouth Harbour to Cardiff Central service on 21 October 1985. Alexandra Dock Junction Yard can be seen in the background, while the area of wasteland visible to the left marks the of Ebbw Junction shed, which was closed in October 1965.

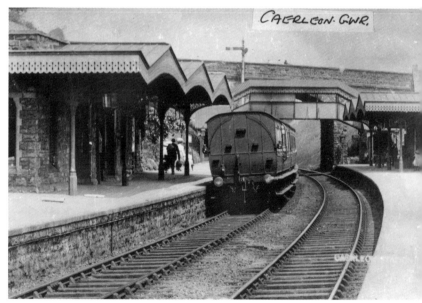

Right: **Caerleon**

On leaving Newport, North & West trains cross the River Usk on an impressive bridge consisting of a series of girder spans resting on massive stone piers. Beyond, the Pontypool, Caerleon & Newport line diverges northwards at Maindee Junction and, having crossed the Usk for a second time, North & West services reach the site of Caerleon station (2¾ miles), which was opened on 21 December 1874. This postcard view, dating from around 1912, shows the up and down platforms, station buildings and road overbridge. Caerleon station was closed to passengers with effect from 30 April 1962 and for freight traffic in November 1965, but plans for reopening have been put forward from time to time.

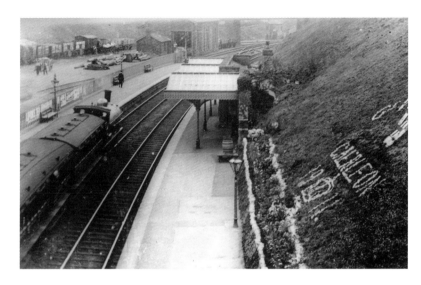

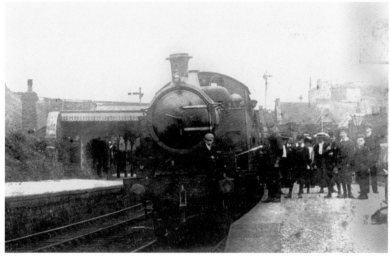

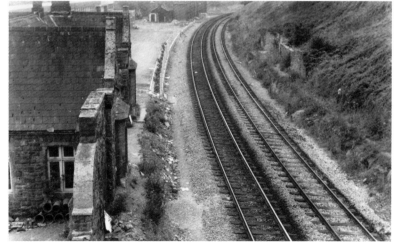

Caerleon

Above left: A view of Caerleon station from the footbridge, showing the up and down platforms, with a local passenger train about to depart. The goods shed can be seen in the distance, while the decorated cutting suggests that the photograph was taken in George V's Coronation year – 1911.

Above right: This postcard view of Caerleon, *c.* 1906, shows what appears to be a 'Birdcage' 2-4-2T standing in the station; these locomotives acquired their nicknames because of their large cabs.

Right: A post-closure view of Caerleon station, showing the derelict facilities from the road overbridge.

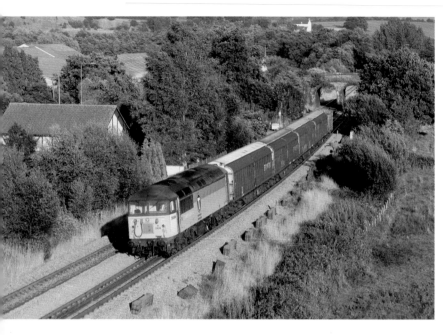

Right: **Ponthir**
Class '60' locomotive No. 60037 *Helvellyn* passes Ponthir with the Alexandra Dock to Irvine china clay tanks on 23 July 1995. This train had worked up from Cornwall on the previous day behind class '37' locomotives Nos 37670 and 37669 – the last time that class 37s had been booked for this working.

Left: **Ponthir**
Following the east side of the Afon Llwyd, trains pass the site of Ponthir station (4¼ miles). This wayside stopping place was opened on 1 June 1878 and closed with effect from 30 April 1962. The photograph, taken in superb evening light on 5 August 1998, shows class '56' locomotive No. 56064 passing Ponthir, with a featherweight 4.04 p.m. Avonmouth to Warrington (via Alexandra Dock Junction) Enterprise service on 5 August 1998. Piles of steel sleepers have been stacked beside the line in readiness for track relaying on this section of line.

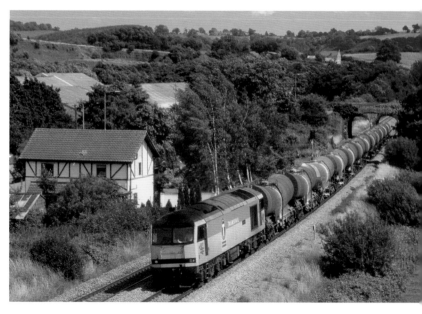

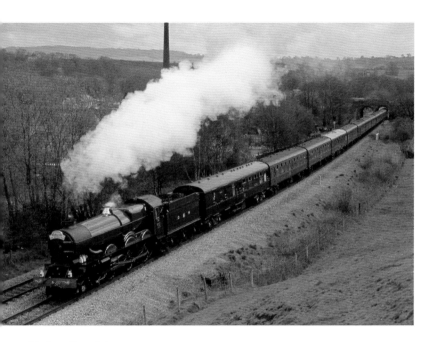

Left: Ponthir

'King' class 4-6-0 No. 6024 *King Edward I* is a fine sight as it passes Ponthir in miserable weather conditions with the 9.00 a.m. Pathfinder Tours Worcester Shrub Hill to Gloucester (via Newport and Hereford) 'Severn-Wye' railtour on 12 April 1993.

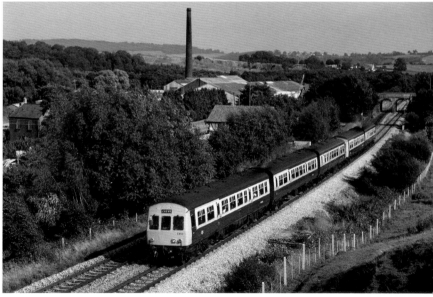

Right: Ponthir

In the 1970s and 1980s, North & West passenger services on the 139-mile route from Cardiff to Crewe were often worked by lengthy multiple unit formations – sometimes including vehicles that were being 'run in' after repairs at Crewe Works. This view of Western Region class '101' sets C814 and C806 was taken at Ponthir on 4 September 1986. Although 'Crewe' is displayed on the destination blind, the five-car train was in fact the 3.40 p.m. Cardiff Central to Shrewsbury service – 95 miles of rattle and vibration. Set C814 comprised motor composite No. 53335, trailer composite No. 59123 and motor brake second No. 53319, while set C806 was formed of motor composite No. 51808 and motor brake second No. 51799. These multiple unit vehicles had been designed for short-distance suburban services rather than long-distance cross-country work, the general opinion being that they were much inferior to the steam-hauled trains that they had superseded.

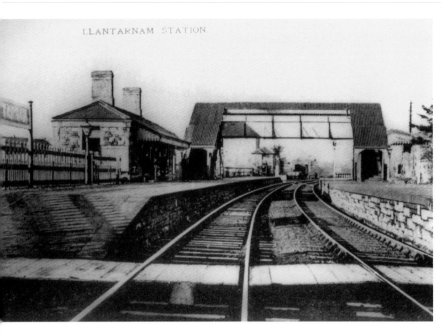

LLANTARNAM STATION.

Left: Llantarnam

Following the east side of the Afon Llwyd, northbound trains pass the site of a now-closed station at Llantarnam (5½ miles), which was deleted from the railway system with effect from 30 April 1962. The photograph, from an Edwardian hand-tinted postcard, depicts Llantarnam station around 1909. Like other stopping places on the Pontypool, Caerleon & Newport line, it was a typical Great Western station, with standard hip-roofed station buildings and a plate girder footbridge. In 1878, the Great Western constructed a connecting spur between Llantarnam and the Monmouthshire Railway & Canal Co. line on the west side of the valley; Eastern Valleys services were then diverted onto the Pontypool, Caerleon & Newport route, while the lower section of the Monmouthshire Railway was closed to passenger traffic – although it retained considerable importance as a freight-only link for traffic to and from Newport Docks.

Right: Cwmbran

Cwmbran (6½ miles), the next stopping place, has a relatively complicated history. The first station, opened by the Monmouthshire Railway & Canal Company on 1 July 1852, was replaced by a new station on 1 August 1880; this new facility was sited on the spur that linked the Pontypool, Caerleon & Newport line to the nearby Monmouthshire Canal & Railway route. The 1880 station was itself closed with effect from 30 April 1962, but a new station was opened on 12 May 1986, this new stopping place being sited on the Pontypool, Caerleon & Newport line. The accompanying picture shows the standard Great Western station building provided at the 1880 station.

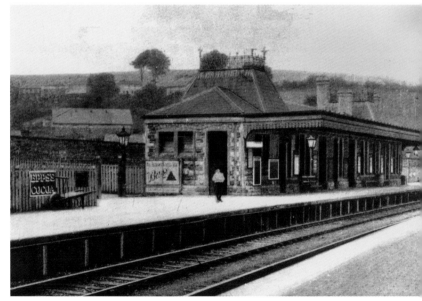

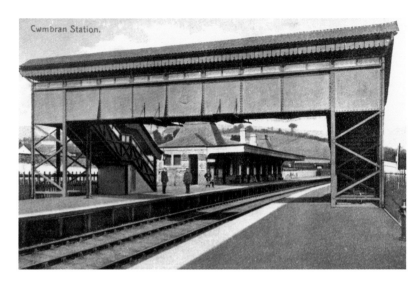

Cwmbran Station.

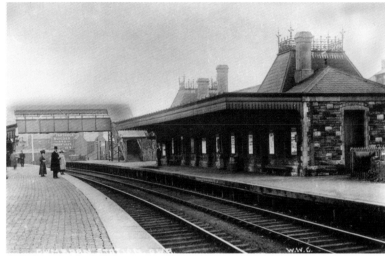

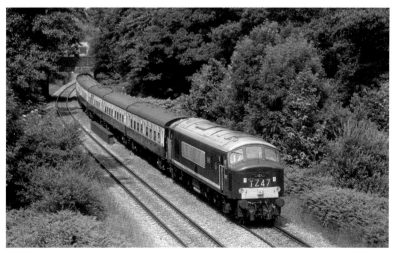

Cwmbran

Above left: A *c.* 1912 postcard view of the 1880 Cwmbran station, showing the plate girder footbridge.

Above right: A further view of the station during the early 1900s.

Right: On Sunday 26 June 1999, the 8.33 a.m. Manchester Piccadilly to Cardiff Central service was due to be worked by class '37' locomotive No. 37029 instead of the normal 'Sprinter' unit in connection with the inaugural rugby match at the new Millennium Stadium. In the event, No. 37029 worked as far south as Crewe, where it was removed after suffering low power. The preserved class '45' locomotive No. D172 *Ixion* then worked the train on to Cardiff and is seen here passing Cwmbran.

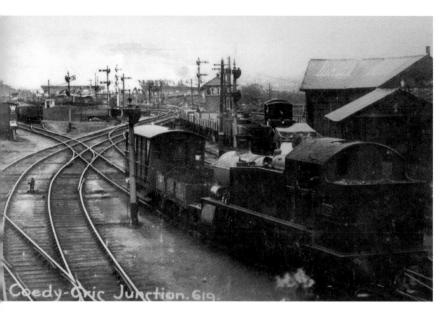

Coed-y-Gric Junction. 619

Left: Pontypool Road – Coed-y-Gric Junction

Following the River Lwyd, the railway climbs northwards through a typical South Wales landscape of bare hill sides and former mining villages, before trains reach Lower Pontnewydd (7¼ miles), the site of a station opened on 21 December 1874 and closed with effect from 9 June 1958. The railway is, at this point, running more or less parallel to the abandoned Monmouthshire Railway & Canal line, which followed a similar route along the valley. This Edwardian postcard depicts Coed-y-Gric Junction, the starting point of the original Newport, Abergavenny & Hereford route, and the site of the Monmouthshire Railway & Canal engine sheds, which were closed as long ago as 1865. Although Coed-y-Gric was bypassed by the Pontypool, Carleon & Newport line, it remained of considerable importance in relation to freight traffic.

Right: Pontypool Road – Panteg Junction

The Pontypool, Caerleon & Newport line continues northwards to Panteg Junction, from where a spur formerly gave access to the Eastern Valleys route. The photograph shows 'Duke' class 4-6-2 No. 71000 *Duke of Gloucester* drifting past Panteg, with the Steamy Affairs Watford to Bristol (via Hereford) 'Welsh Marches Express' railtour on 28 May 2005. No. 71000 was deputising for the unavailable 'A4' class Pacific No. 60009 *Union of South Africa*.

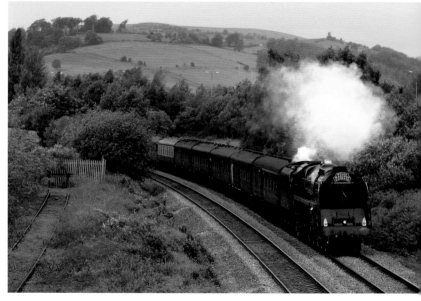

Pontypool Road – The Original Station

The once-important station at Pontypool Road (10 miles) was opened by the Newport, Abergavenny & Hereford Railway on 2 January 1854. It was elevated to junction status on 20 August 1855, when the initial section of the Taff Vale Extension line was opened between Pontypool Road and Crumlin Junction. The Taff Vale Extension was completed throughout to Quakers Yard on 11 January 1858, and it later became part of an east-to-west cross-country route between Pontypool Road and Neath.

By the end of the Victorian period, the Pontypool area had become a busy railway centre, with several stations, sidings and goods yards in the immediate vicinity, in addition to the main line station at Pontypool Road. There were stations at Pontypool Clarence Street on the Taff Vale Extension line, and at Crane Street on the Monmouthsire Railway, together with a number of smaller stations on the surrounding lines. The photograph illustrates the original NA&HR station, which was sited about a quarter-of-a-mile to the south of the present-day stopping place.

Pontypool Road – The New Station

Pontypool Road station was rebuilt on a new site during the Edwardian period, the remodelled facilities being opened on 1 March 1908. The modernised station incorporated a spacious island platform, with terminal bays at each end and through lines on each side. The new station buildings were of standard Great Western design, with extensive canopies over the centre section of the platforms.

In operational terms Pontypool Road was particularly significant in that it was the site of an important motive power depot that normally housed around ninety locomotives. Coded '86G' by British Railways, the depot was sited to the south of the passenger station amid a complex web of sidings and trackwork. The shed building was of unusual design, with two sheds placed end-to-end. The main building was a classic 'covered roundhouse' depot, with an internal turntable that fed a fan of radiating spurs. The building measured around 250 feet by 175 feet at ground level.

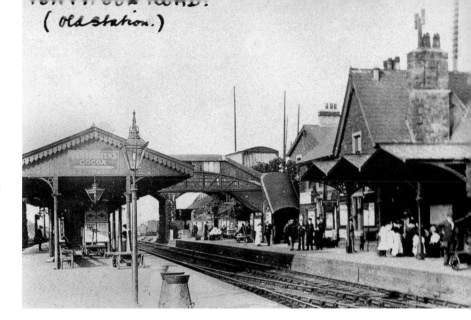

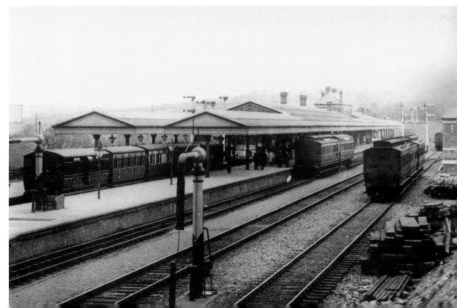

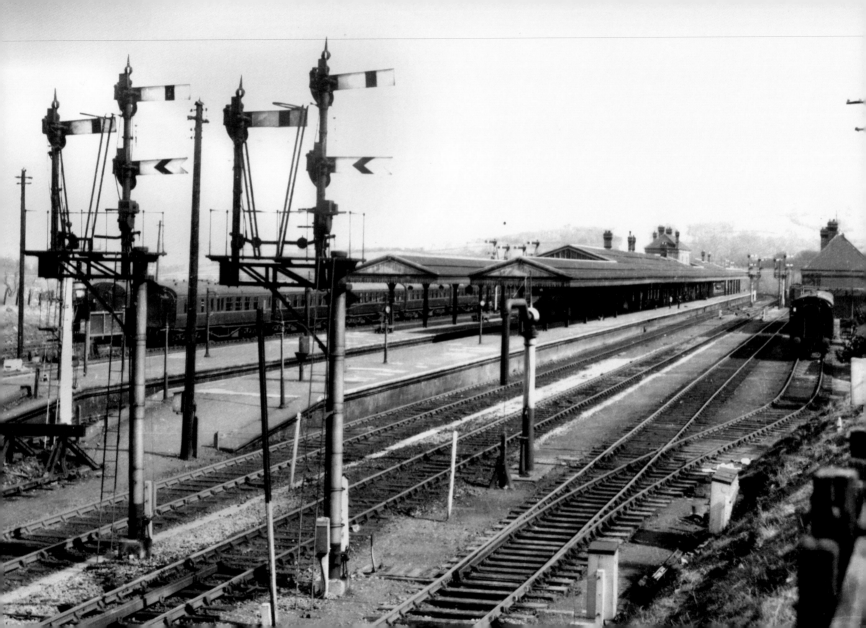

Pontypool Road – Views of the Station

Right: The rear elevation of the main station building, photographed on 1 September 1953. This brick-built structure was linked to the platforms by an underline subway.

Below left & below right: These two 1960s views show the north end of the island platform, with parcels vans in the bay platform.

Opposite: A panoramic view of Pontypool Road station during the early 1960s, looking north towards Hereford with the station approach road visible to the right. Although Pontypool Road remains in operation, the present-day 'Pontypool' station is merely a shadow of its former self, the once extensive facilities having been reduced to little more than the island platform and a simple waiting shelter.

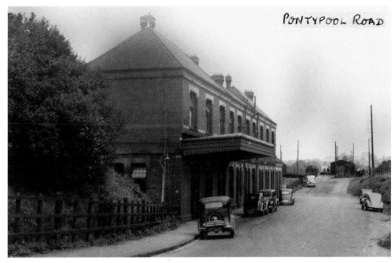

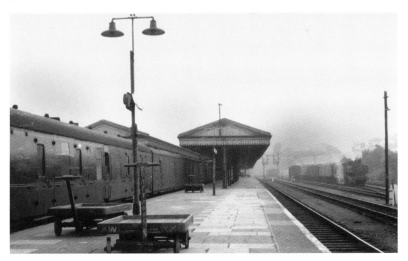

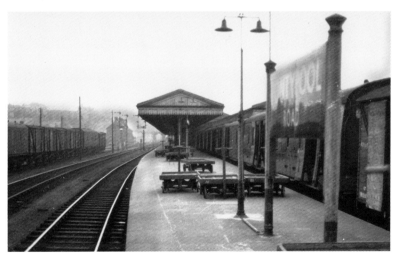

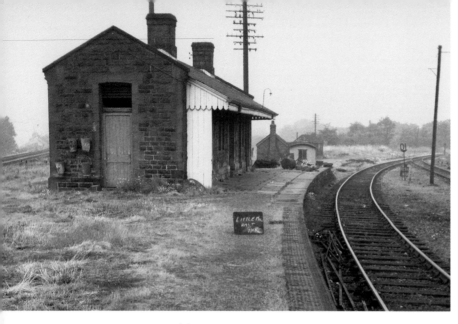

Little Mill Junction

From Pontypool Road, trains proceed north-eastwards along the Newport, Abergavenny & Hereford main line for a distance of 2 miles before reaching the site of Little Mill Junction. The first station was opened on 2 January 1854, and this original stopping place was elevated to junction status on 2 June 1856, when the Coleford, Monmouth, Usk & Pontypool Railway opened its line between Little Mill and Usk. The Usk route was completed to Monmouth on 12 October 1857, and the line was then worked as a 12 mile 4 chain route between Pontypool Road and Monmouth (Troy).

Little Mill station was situated in the 'V' of the junction between the Monmouth and Hereford routes. A curved platform was provided for branch trains, while the up and down main lines ran through the station on the west side of the branch platform. Little Mill station was closed in 1861, but it was subsequently reopened for branch line traffic on 1 May 1883. The station had a staff of ten in 1929, including one class four stationmaster, two porters, four goods shunters and three signalmen. The station building, shown above, was a small stone structure of no architectural pretension, its low-pitched slated roof being swept down over the platform to create a modest canopy. The lower view shows the up and down main lines.

The Monmouth branch was scheduled for closure with effect from 13 June 1955. However, on 28 May ASLEF, the footplatemen's union, called a national strike. A settlement was reached on 14 June, but as this was the day after which the Little Mill to Monmouth route should have closed, there were no 'last day' ceremonies. The branch had, for all intents and purposes, closed on Saturday 28 May, on which day ASLEF had ceased work. Little Mill station was closed with effect from 15 September 1958, although the western end of the Monmouth route was retained in connection with military traffic to and from an ordnance depot at Glascoed.

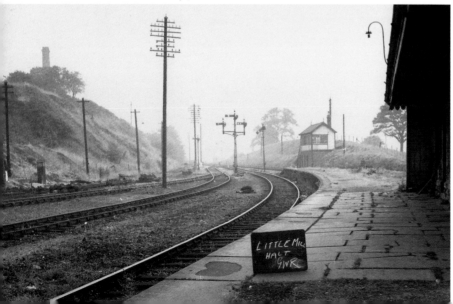

Left: **Nantyderry**
Heading northwards from Little Mill, trains reach the site of Nantyderry station (14¼ miles), which was opened by the Newport, Abergavenny & Hereford Railway on 2 January 1854 and closed with effect from 9 June 1958. The picture shows class '158' unit No. 15830 passing Nantyderry while working the 5.23 a.m. Holyhead to Cardiff service on 23 August 2003. The unit is wearing 'Alphaline' livery, complete with large 'A' graphics that were partially interrupted by the windows.

Right: **Nantyderry**
Class '27' locomotive No. 37197 emerges from the bushes at Nantyderry with the 9.13 a.m. Crewe to Cardiff Central rugby special on 23 August 2003. The locomotive is carrying the short-lived Riley & Sons two-tone green livery. This engine has had its fair share of liveries since privatisation, having appeared in West Coast RC maroon for working the Royal Scotsman, and then Direct Rail Services blue.

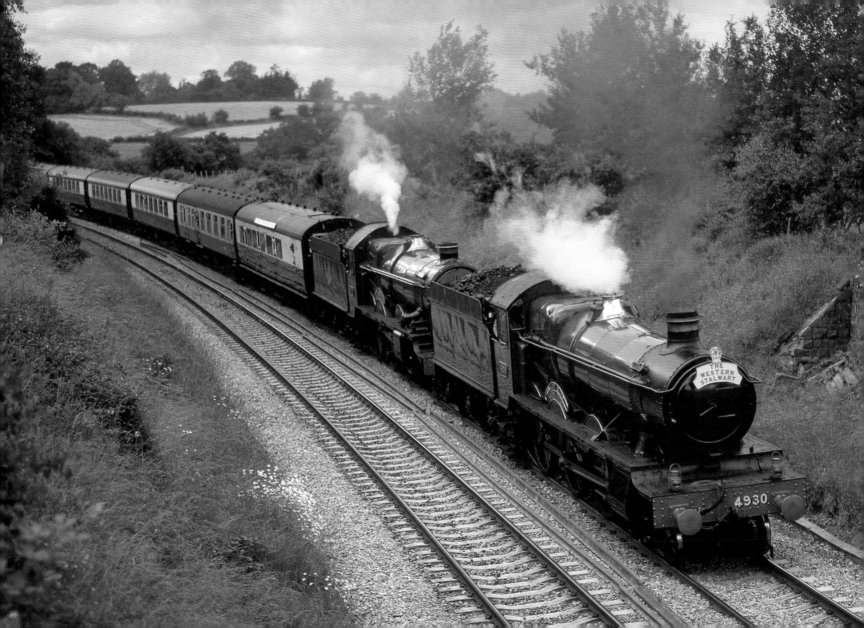

Abergavenny Monmouth Road

Abergavenny (19½ miles), the next stopping place, is a relatively busy station that dates back to the opening of the NA&HR line on 2 January 1854. The station is still staffed, and the original Newport, Abergavenny & Hereford Railway station building survives intact on the up platform, this substantial, two-storey Italianate-style buildings being of stone construction, with flanking single-storey wings on each side. There is an additional waiting room on the down platform, while the up and down sides of the station are linked by a footbridge that incorporates both lattice and plate girder spans. In recent years, the station has generated over 300,000 passenger journeys per annum.

Abergavenny Junction

Sited a little over 1 mile beyond Abergavenny Monmouth Road, Abergavenny Junction was opened as an interchange point between the NA&HR main line and the London & North Western branch to Tredegar, although the station did not appear in public timetables until March 1864. The station was resited on 20 June 1870. The photograph shows a Great Western 4-4-0 locomotive entering Abergavenny Junction around 1912. North-eastwards, the route ascends towards Llanvihangel Summit, then falls towards the Herefordshire border on gradients of 1 in 100.

Opposite: Nantyderry

'Hall' class 4-6-0 No. 4930 *Hagley Hall* (leading) and 'Castle' class 4-6-0 No. 7029 *Clun Castle* pass Nantyderry with the Kidderminster to Cardiff 'Western Stalwart' railtour on 6 July 1985.

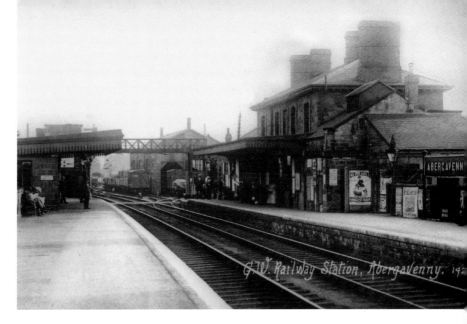

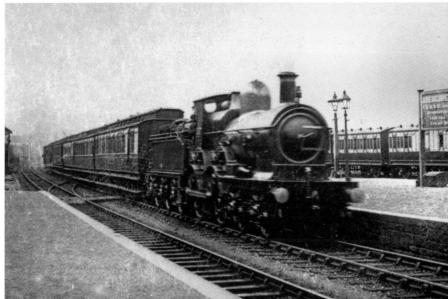

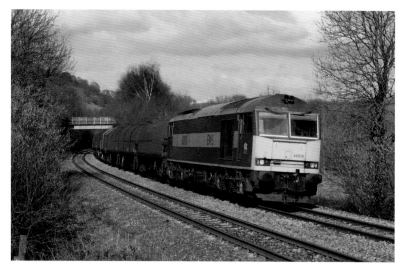

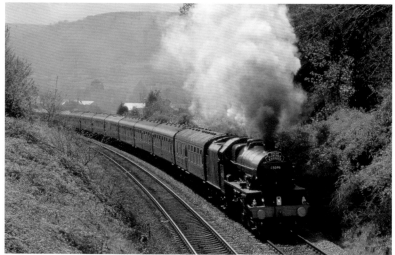

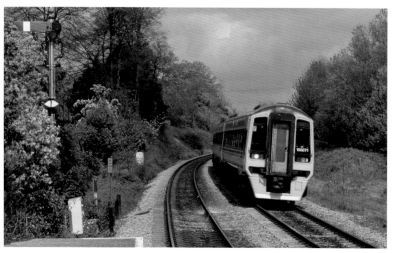

Abergavenny – Steam & Diesel Power

Above left: Class '60' locomotive No. 60018 coasts downhill past Triley Mill, near Abergavenny, while hauling the 9.29 a.m. Dee Marsh to Margam empty steel train on 25 February 2006.

Above right: Former London Midland & Scottish Railway 'Jubilee' class 4-6-0 No. 45596 *Bahamas* storms past Abergavenny with the 7.13 a.m. Pathfinder Tours Trowbridge to Crewe 'Welsh Marches Express' railtour on 23 April 1994.

Below left: Dark threatening clouds hang over Abergavenny as class '158' unit No. 158871 approaches the station with the 10.33 a.m. Manchester Piccadilly to Cardiff Central Regional Railways service on 23 April 1994.

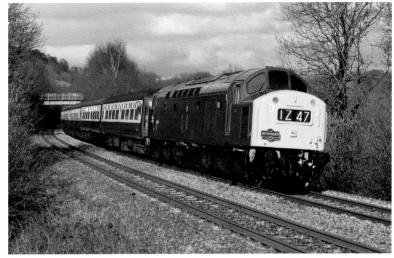

Llanvihangel

Right: Class '40' locomotive No. 40145 rounds the curve at Triley Mill with the 6.01 a.m. Crewe to Cardiff Central 'Welsh Whistler' railtour on 25 February 2006.

Below left & below right: As trains continue north-eastwards they pass a succession of now-closed stations, including Llanvihangel, Pandy, Pontrilas, St Devereaux and Tram Inn. These stations were all opened by the NA&HR on 2 January 1854, and all five were deleted from the British Railways network with effect from 9 June 1958. The photographs show Llanvihangel during the early years of the twentieth century, and about four years after closure.

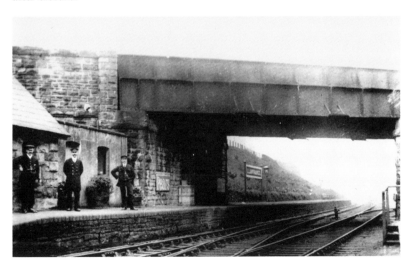

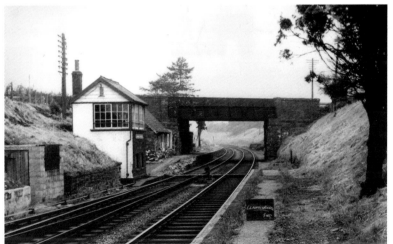

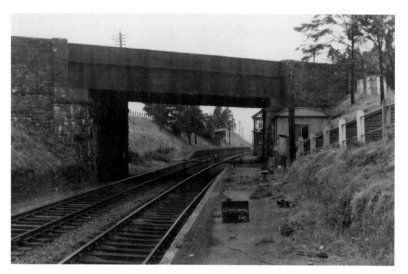

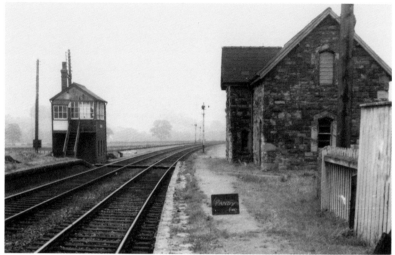

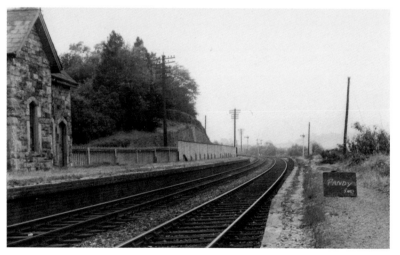

Llanvihangel and Pandy Stations

Above left: Another post-closure view of Llanvihangel (23½ miles); this station had staggered platforms and substantial, stone-built station buildings.

Above right: Pandy station (26 miles) was opened by the NA&HR on 2 January 1854 and closed with effect from 9 June 1958. This post-closure photograph shows the main station building, which, like others on the Newport, Abergavenny & Hereford route, was solidly constructed of local stone.

Left: A further view of Pandy station after closure.

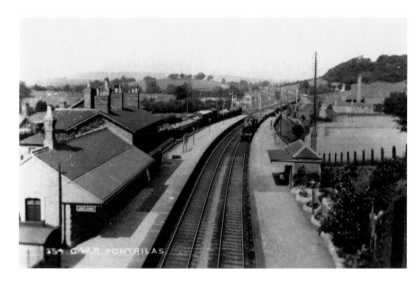

Pontrilas

Continuing north-eastwards, trains reach the site of the abandoned station at Pontrilas (31 miles). Opened by the NA&HR on 2 January 1854, this station was the junction for branch line services to Hay-on-Wye via the Golden Valley Railway – the latter company having been incorporated on 13 July 1876, with powers for the construction of a line from Pontrilas to Dorstone – a distance of 10 miles 56 chains. After many delays, the Golden Valley line was belatedly opened on 1 September 1881, while in 1889 the line was extended from Dorstone to Hay-on-Wye. In its heyday, Pontrilas boasted three platforms, the up platform being equipped with a terminal bay for branch line traffic. The main station building, which was similar in design to that at Abergavenny, was on the up side, and there was a much smaller waiting room on the opposite platform – the latter structure being of GWR design, suggesting that it had been a later addition. These two photographs are both looking northwards during the early years of the twentieth century.

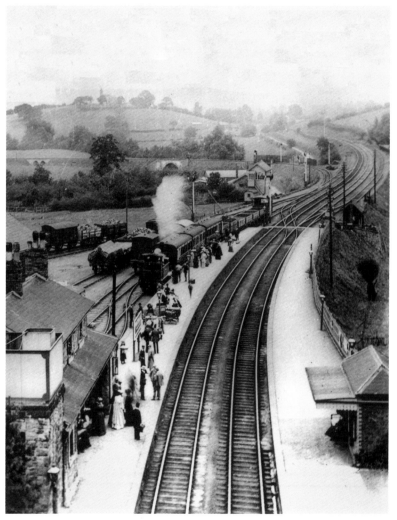

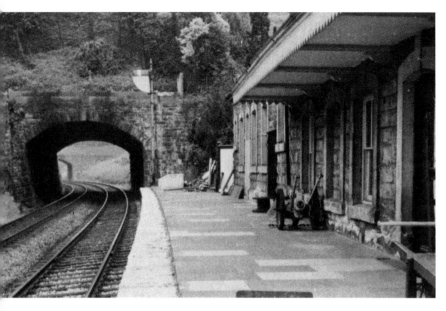

Right: **Pontrilas**

A further view of Pontrilas station building around 1962, looking north towards Hereford. The rebuilt single-storey wing is visible to the left of the picture, while the signal box can be glimpsed in the background.

Left: **Pontrilas**

The Golden Valley line lost its passenger services in December 1941, while Pontrilas was closed to passengers with effect from 9 June 1958, goods traffic being handled until October 1964. This post-closure view of Pontrilas is looking southwards along the up platform towards Pontrilas Tunnel, which had a length of just 37 yards. The station building, visible to the right, was extensively rebuilt during the early years of the twentieth century, the water tower that can be seen in the previous photograph being replaced by a reconstructed single-storey extension at the south end of the building.

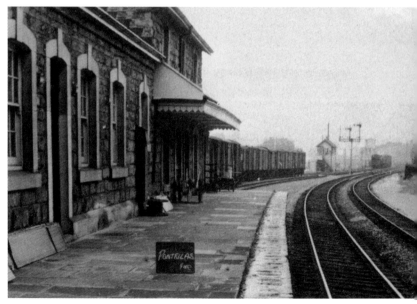

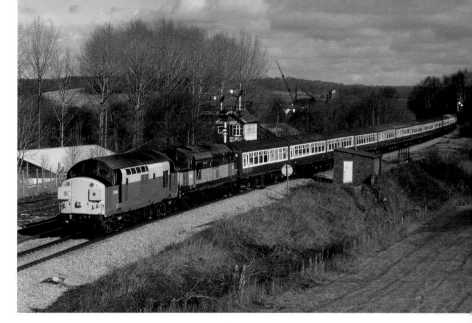

Pontrilas

Class '37' locomotives Nos 37038 and 37197 approach Pontrilas with the 8.50 a.m. Manchester Piccadilly to Cardiff Central football special on 2 March 2003. This service was run in connection with the Worthington Cup Final played between Liverpool and Manchester United at the Millennium Stadium, which, incidentally, Liverpool won by two goals to nil. Although Pontrilas station had been closed in 1958, the signal box and loop remained intact, together with a fine collection of Great Western semaphore signals. The all-timber signal cabin was supplied by signalling contractors Mackenzie & Holland.

St Devereux

St Devereux station (34½ miles) was opened by the Newport, Abergavenny & Hereford Railway on 2 January 1854 and closed with effect from 9 June 1958. The photograph is looking south towards Newport, probably around 1930. The main station building, on the down side, was of typical NA&HR design, while the modest goods yard, also on the down side, was able to deal with a range of traffic including coal, livestock, horseboxes and general merchandise.

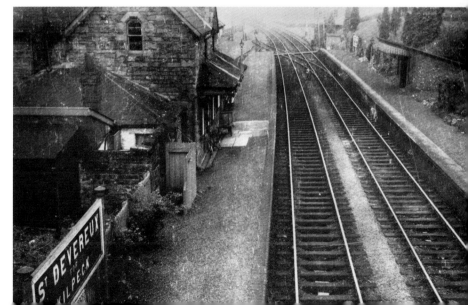

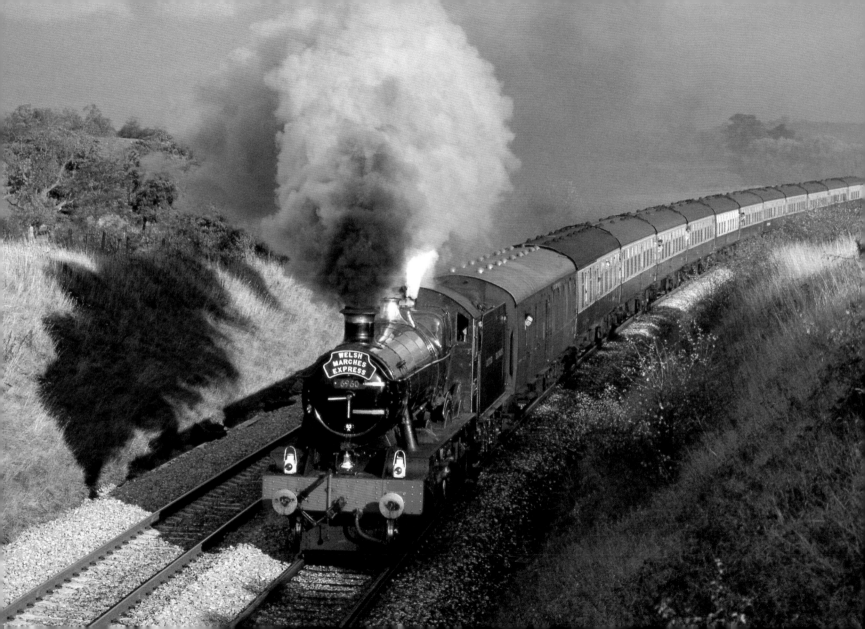

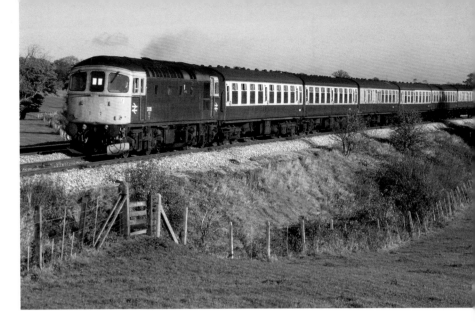

St Devereux

Class '33' locomotive No. 33015 heads southwards through the Herefordshire countryside at St Devereux with the 10.03 a.m. Crewe to Cardiff Central service on 10 November 1984. These trains remained locomotive-hauled for a further two years before diesel multiple units assumed control of the service – a very poor substitute for six MkI corridor coaches!

Tram Inn

Tram Inn (26¾ miles) was opened on 2 January 1854 and closed with effect from 9 June 1958. The layout here was unusual insofar as the up platform was interrupted by a level crossing; the main station building, which contained the booking office and stationmaster's house, was on the north side of the crossing, while the waiting room was sited on the detached southern section of the platform. The two platforms were, moreover, staggered, with the down platform on the north side of the crossing. The picture is looking northwards from the up platform, the goods shed being visible beyond the level crossing, while the down platform, with its diminutive waiting room, can be seen in the distance.

Opposite: St Devereux

'Hall' class 4-6-0 No. 6960 *Raveningham Hall* passes St Devereux with steam to spare while hauling the 'Welsh Marches Express' railtour on 10 November 1984. No. 6960 worked the first part of the tour from Hereford to Newport and return, while Bulleid 4-6-2 No. 35028 *Clan Line* worked the train between Shrewsbury and Hereford.

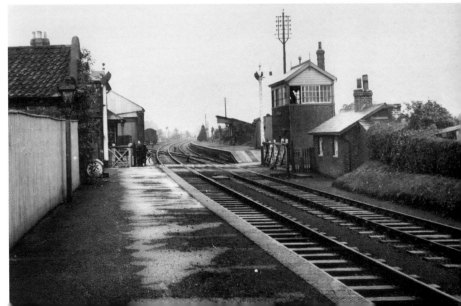

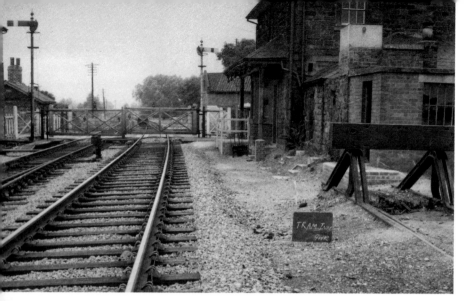

Tram Inn & Rotherwas Junction

The upper view is a post-closure photograph of Tram Inn station, looking south towards Newport during the early 1960s. The main station building features prominently to the right, while the GWR signal box can be glimpsed on the extreme left. The buffer stop beside the station building was sited at the end of the goods shed siding – goods being handled here until October 1964. The lower picture is a detailed study of Tram Inn Signal Box. This standard Great Western gable-roofed cabin was sited on the down side in convenient proximity to the level crossing.

From Tram Inn, trains continue north-eastwards to Red Hill Junction, where they leave the NA&HR route and diverge eastwards onto the London & North Western line to Rotherwas Junction. Known variously as 'The Hereford Curve', 'The Hereford Loop' or 'The Rotherwas Curve', the connecting line from Red Hill Junction was opened for goods traffic on 23 July 1866 and for passengers just one week later. The Hereford Curve joins the Hereford, Ross & Gloucester line at Rotherwas Junction – the site of an ordnance factory that was used in both world wars. The factory was served by a siding connection, and there was a special factory station within the works. The ordnance factory generated considerable amounts of passenger traffic in the form of workers' specials, which conveyed the predominantly female workforce to and from Leominster and Ross-on-Wye.

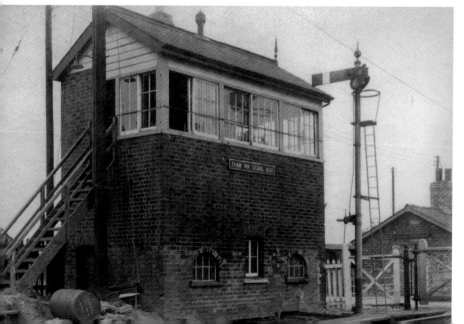

Hereford – The Eign Bridge

Nearing Hereford, trains cross the River Wye on the Eign Bridge, which is the third to occupy the site. The original bridge had incorporated six timber spans, but this single-track structure was replaced by a double-track bridge in 1865. The new bridge featured a mixture of masonry arches and plate girder spans, the main section, over the river, having two 43 feet 6 inch spans and a central span of 72 feet. The main girder spans were supported on concrete filled cast-iron piers and there were, in addition, four masonry arches; three of these were on the south bank of the river while the fourth was sited on the north bank.

Although the 1865 bridge was more robust than its immediate predecessor, it was not strong enough to carry large locomotives such as the GWR 'Castle' class 4-6-0s and, in order to rectify this situation, further rebuilding work was carried out during the early 1930s. It was decided that the three 1865 girder spans would be replaced by two clear spans, each of 79 feet 6 inches, resting on a new pier in the centre of the river. Work commenced in 1931 and in the following November the new girder sections, each weighing 86 tons, were manoeuvred into position with the aid of travelling breakdown cranes.

This operation was carried out over two weekends, the engineers having been given possession of the site from 11.00 p.m. on Saturday 14 November until midnight on Sunday 15 November 1931. In the meantime, fabrication of the girders that would carry the down line had been taking place at nearby Rotherwas sidings, and these two 86 ton spans were then moved into position by rail. The reconstruction work was completed during the following weekend, when the new up side spans were inched into place. The upper photograph shows the bridge in March 2007, while the lower view provides a more detailed view of the main girder spans.

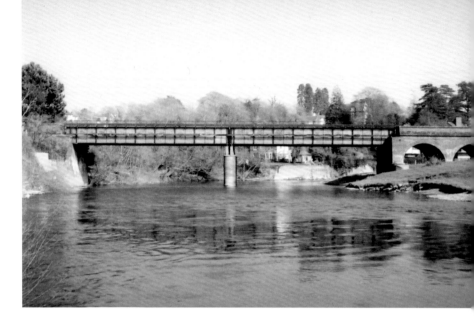

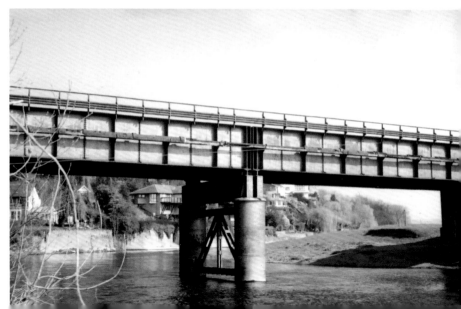

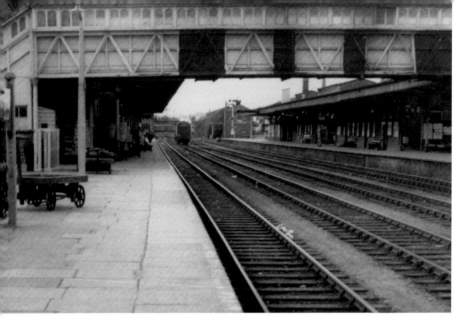

Hereford Barr's Court

Having crossed the river, trains soon reach Barr's Court station and the start of the former Shrewsbury & Hereford Joint line, Barr's Court station having been regarded as part of the joint London & North Western–Great Western system. Situated some 43½ miles from Newport, Hereford Barr's Court is aligned from south-east to north-west, the southern approaches to the station being spanned by a girder bridge with brick abutments that carries Commercial Road over the up and down running lines. The station derived its name from neighbouring Barr's Court house, which had once the home of the la Barre family, but later became a private school.

Hereford Barr's Court incorporates three lengthy through platforms, the up platform on the west side having just one face, whereas the down platform is an island with tracks on either side. The platforms are numbered in sequence from 1 to 4: Platforms 1 and 2 are the two sides of the island platform, while Platform 3 serves the up main line and Platform 4 is a terminal bay at the north end of the up platform. The black-and-white picture is looking northwards along Platform 3, while the colour view, taken in 2007, shows a class '80' locomotive passing through the station on the centre roads with a down freight working. The island platform can be seen to the right, with a class '180' unit alongside Platform 1.

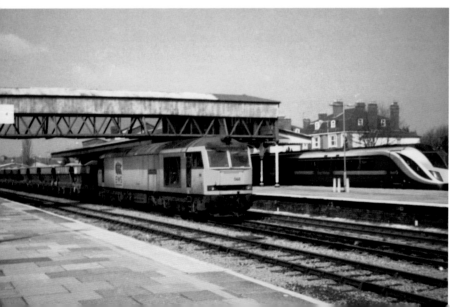

Hereford Barr's Court – The Main Station Building

The most attractive feature of Hereford station is perhaps its ornate Tudor Gothic-style station building. This distinctive two-storey structure is sited on the up side, and it towers above the adjacent platforms; its height is accentuated by a steeply pitched gable roof, and a profusion of tall chimney stacks. Although Barr's Court station was opened on 6 December 1853, the station building was built in 1855 as a 'joint station' for use by the Shrewsbury & Hereford and Hereford, Ross & Gloucester railways, the HR&GR line having been officially opened throughout its length from Grange Court to Hereford on 1 June 1855. The upper view shows the rear elevation of the building around 1912, while the colour photograph was taken in 2007.

The building is of red-brick construction with Bath stone dressings, and it was designed by local architect Thomas Mainwaring Penson (1817–64). In its report on the opening of the HR&GR line, *The Hereford Times* stated that the building contained 'spacious rooms for officials and the convenience of travellers'. The ground floor included a booking office measuring 39 feet 6 inches by 21 feet 6 inches, together with a first-class refreshment room; a second-class refreshment room; first-class ladies' and gentlemen's waiting rooms; a second-class waiting room; a parcels and luggage office; guards' and porters' rooms; and a kitchen. There were also 'offices for the stationmaster, a telegraph office, and various others suited for the convenience of passengers', while the upper floor contained 'two large boardrooms' measuring 40 feet by 17 feet, and 25 feet by 19 feet 6 inches. There was, in addition, a stationmaster's residence and 'the requisite offices for the officials'.

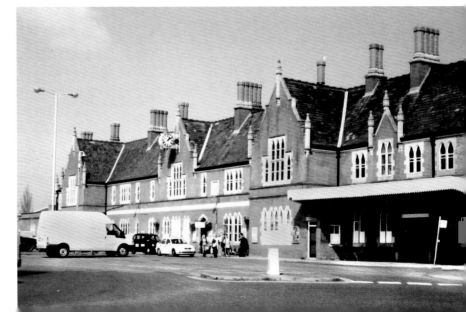

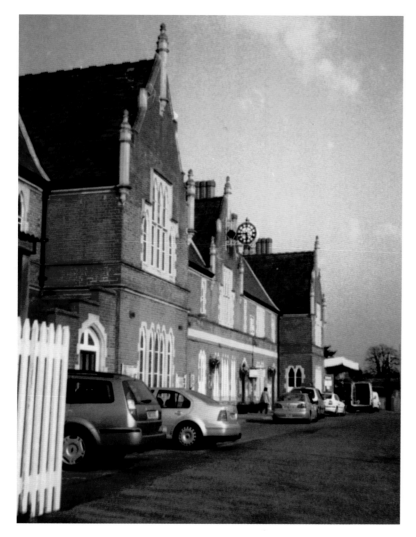

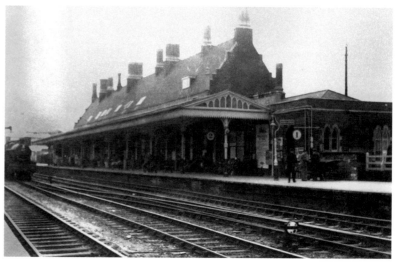

Hereford Barr's Court – The Main Station Building

Two further views of Hereford Barr's Court station building. Examination of the brickwork suggests that the south end of the building has been extended at some time, presumably to provide additional rooms on the first floor. Large station buildings of similar size and shape were erected at Shrewsbury and Chester; Shrewsbury is another Gothic-style structure, whereas Chester General has classical features. These impressive structures, which have remained in use as part of the North & West route, were much more than station buildings in that they were also intended to serve as company offices for undertakings such as the Shrewsbury & Hereford and Hereford, Ross & Gloucester railways. When these formerly independent concerns were absorbed by larger companies, spacious station buildings, such as those at Hereford Barr's Court, continued to provide a range of useful office accommodation.

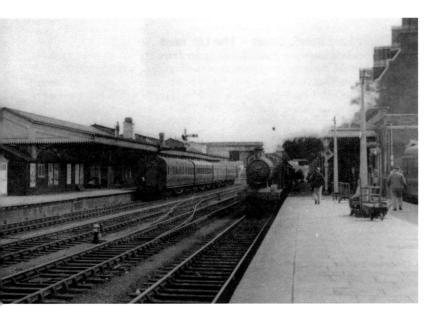

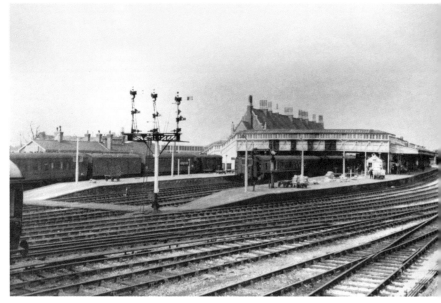

Left: Hereford Barr's Court – The Down Side Building
In Victorian days, the island platform was equipped with waiting and refreshment rooms for first- and second-class travellers, together with a ladies' waiting room and toilets for both sexes. At first glance, the brick buildings on the down platform appear to be standard Great Western late-Victorian structures, although, on closer examination, it is clear that some attempt was made to emulate the Gothic appearance of the main station building on the up side. The up and down sides of the station are linked by a fully roofed lattice girder footbridge, and extensive canopies are provided on both platforms.

Right: Hereford Barr's Court
A view of the station, photographed from the south-east around 1963. The railway infrastructure in and around Hereford was surprisingly complex. Barr's Court station boasted a multiple track layout, with four tracks between the main up and down platforms and further goods avoiding lines to the east of the island platform. The up and down goods lines extended northwards, alongside the up and down main lines, for a little under 1 mile to Barr's Court Junction North, where a double-track loop line from Red Hill Junction converged from the south. The loop line, which bypassed Barr's Court station, served the former Newport, Abergavenny & Hereford Railway station at Hereford (Barton), which was closed to passengers in the 1890s but survived for many years thereafter as a goods station. Barton was also the site of the former NA&HR locomotive works, which became a Great Western motive power depot after the amalgamation of the GWR and West Midland companies in 1863.

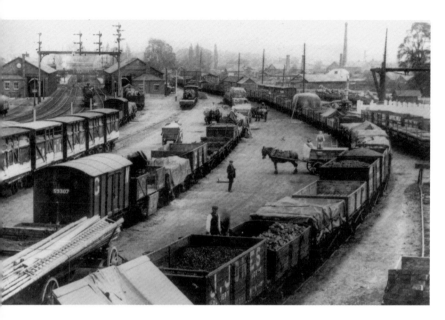

Left: Hereford Barr's Court – The Up Yard

Hereford boasted extensive goods-handling facilities, the main goods yard being sited to the north of the passenger station on the up side, while a separate 'Down Yard' was situated on the opposite side of the running lines. Both yards contained brick-built goods sheds and these two structures were physically connected by a girder footbridge. The 'Up Yard' was more spacious than its counterpart on the down side, with considerably greater capacity for coal and other forms of wagon load (or 'mileage') traffic. The Up Yard contained ten dead-end sidings, which were numbered from one to ten. Sidings 1 and 2 roads were brake van sidings, while 'No. 3 Road' was a much longer siding that had traditionally been used for timber traffic. Sidings 4, 5 and 6 were employed as marshalling sidings during shunting operations, while Nos 7, 8 and 9 were used for coal and other 'mileage' traffic. Finally, Siding No. 10 was the 'Goods Shed Road', which served the Up Goods Shed.

Right: Hereford Barr's Court – The Up Yard

This recent view of the former Up Yard on 2 June 2009 reveals that Barr's Court has retained much of its Victorian railway infrastructure, and some of the goods yard sidings have remained in situ, although originating freight traffic now appears to be a thing of the past. Class '175' unit No. 175102 is departing from the station with the 1.10 p.m. Milford Haven to Manchester Piccadilly Arriva Trains Wales service.

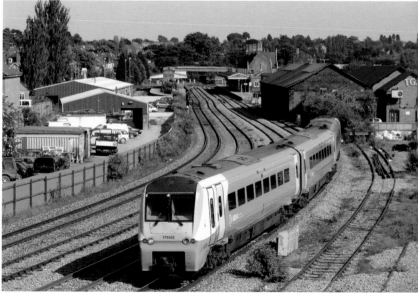

Hereford Barr's Court

An unidentified class '33' locomotive enters Barr's Court with a Cardiff to Crewe service during the late 1970s, while a southbound oil tank train waits in the centre roads. Hereford issued around 200,000 tickets per annum during the Edwardian period, although sales of ordinary singles and returns had halved by the 1930s. At the same time, the number of season ticket sales increased from 286 in 1923 to 613 by 1936. In 1938, Hereford issued 98,155 ordinary tickets and 582 seasons, suggesting that the overall level of passenger usage at the end of the end of the 1930s was similar to that at the very start of the twentieth century. As far as freight traffic was concerned, the GWR regarded Hereford Barr's Court and Barton stations as a single goods yard, and in 1913, Hereford dealt with 114,229 tons of freight, rising to 139,000 tons per year during the 1920s and over 200,000 tons per annum by the early 1930s.

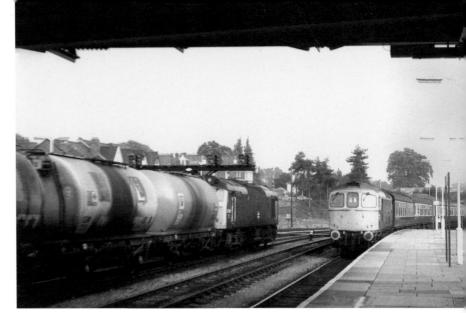

Hereford – Ayleston Hill Signal Box

The passenger station was signalled from two signal cabins, which were sited to the north and south of the platforms and known as 'Hereford Station Signal Box' and 'Ayleston Hill Signal Box' respectively. Both of these hip-roofed cabins were of similar design, although Ayleston Hill Box, which was sited near the former broad gauge engine shed, was of noticeably 'squat' appearance, its operating floor being only a few feet above ground level, so that the signalmen were able to obtain an unimpeded view beneath the adjacent road overbridge.

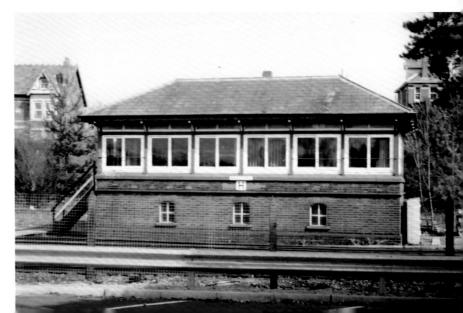

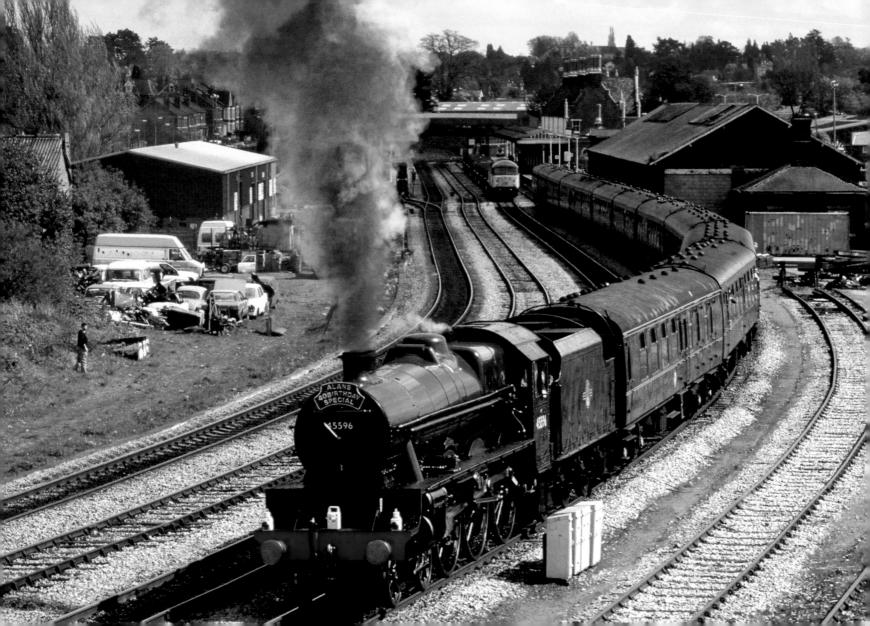

Moreton-on-Lugg

Leaving Hereford, trains pass Shelwick Junction, where the Worcester & Hereford route diverges eastwards on its way to Worcester via Ledbury and Great Malvern. The completion of the Worcester & Hereford Railway on 13 September 1861 gave Hereford a direct rail link to London, and InterCity services still run through to Paddington, although there is little attempt to connect with North & West services.

Turning onto a north-westerly heading, the Shrewsbury & Hereford line runs through verdant, pastoral countryside as its follows the peaceful Lugg valley towards the now closed stopping place at Moreton-on-Lugg (47¾ miles). When opened on 6 December 1853, this station had been known simply as 'Moreton', but its name was subsequently changed to 'Moreton-on-Lugg' to prevent confusion with other Moretons in Dorset, Cheshire and Gloucestershire. The station had up and down platforms for passenger traffic, the main station building being on the up side. The modest goods yard, which was also on the up side of the line, contained two sidings, while the minor road from Marden to Moreton-on-Lugg crossed the line on the level at the north end of the platforms.

Minor structures at Moreton-on-Lugg included a weigh-house, a cattle loading dock and a 1-ton yard crane. A standard GWR gable-roofed signal cabin was situated to the north of the level crossing on the down side, and further sidings were provided on the north side of the level crossing in connection with a War Department storage depot. Moreton-on-Lugg was never a busy station, and its passenger services were withdrawn with effect from 9 June 1958. Goods traffic was dealt with until September 1964, after which the station continued to handle private siding traffic in connection with the above-mentioned Ministry of Defence establishment. The upper photograph is looking northwards during the early 1960s, while the lower view is looking south towards Newport.

Opposite: Hereford Barr's Court

Ex-LMS 'Jubilee' class 4-6-0 No. 45596 *Bahamas* pulls away from Hereford station while working the 7.13 a.m. Pathfinder Tours Trowbridge to Crewe 'Welsh Marches Express' railtour on 23 April 1994, which it worked between Worcester and Crewe. During the water stop at Hereford someone has changed the 'Welsh Marches Express' headboard to one that reads 'Alan's 40th Birthday Special'! Class '56' locomotive No. 56052 can be glimpsed in the background sitting in the centre road during its long layover with the 11.00 a.m. Margam to Dee Marsh steel coils train.

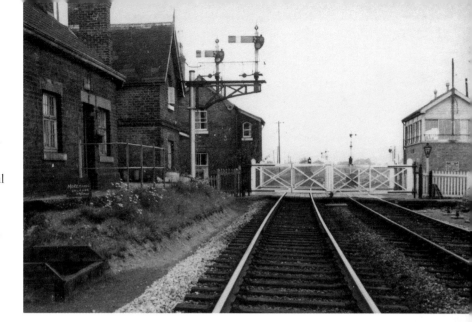

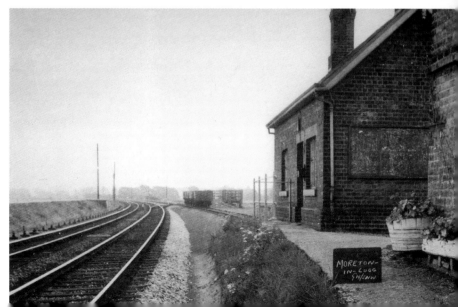

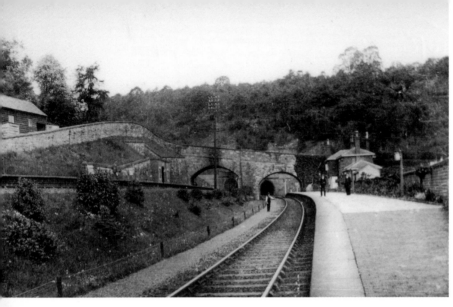

Dinmore

On leaving Moreton-on-Lugg, the railway takes up a northerly heading as it follows the meandering River Lugg. Nearing Dinmore, the up and down lines part company in order to pass through the 1,096-yard Dinmore Tunnels on different levels. This unusual arrangement dates from the doubling of the tunnel section in 1893, when an entirely new single-line bore was provided for the up line. The two single-line tunnels at Dinmore are on differing alignments; the original Shrewsbury & Hereford tunnel, which now carries down or southbound traffic, has a gradient of 1 in 100, whereas the later tunnel built for northbound traffic was constructed on an easier gradient of 1 in 134. At the south end, the 1893 tunnel is at a higher level than the old bore, whereas at the northern end the situation is reversed, in that the 1893 tunnel emerges at a slightly lower level than its older counterpart!

The upper picture shows Dinmore station (50½ miles), which was opened on 6 December 1853 and closed to passengers with effect from 9 June 1958. The station was situated at the south end of the tunnel, the main station building being on the down side, while the up platform and its waiting shelter were sited at a higher level beside the 1893 line. The goods yard, with a full range of facilities for coal, furniture, vehicles, livestock and general merchandise traffic, was on the down side, and it remained in use until 1964. The lower photograph is a post-closure view of the station building, with the tunnel mouth visible in the distance.

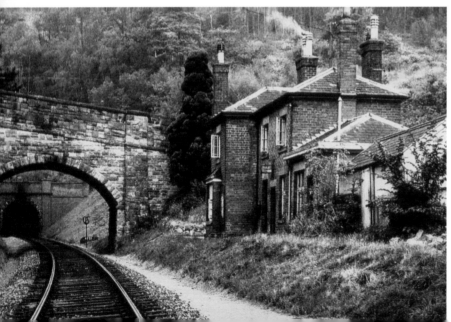

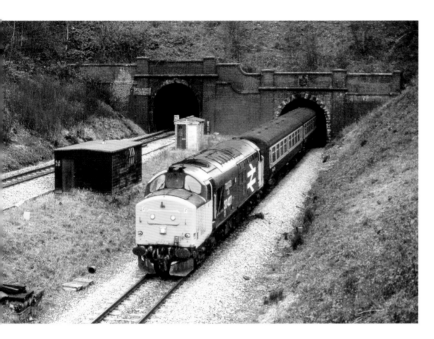

Left: **Dinmore**

Class '37' locomotive No. 37427 *Bont y Bermo* emerges from the southern portal of Dinmore Tunnel at the head of the 9.15 a.m. Liverpool Lime Street to Cardiff Central Regional Railways service on 31 January 1989. At that time trains on the North & West route were regularly formed of BR Mk.1 coaches hauled by class 37 locomotives in lieu of the booked 'Sprinter' units.

Right: **Dinmore**

Class '175' unit No. 175116 emerges from Dinmore Tunnel with the 10.33 a.m. Holyhead to Cardiff Central Arriva Trains Wales service on 2 June 2009. No. 175116 was the final production 175 unit, and one of the last to retain its original livery (albeit branded Arriva Trains).

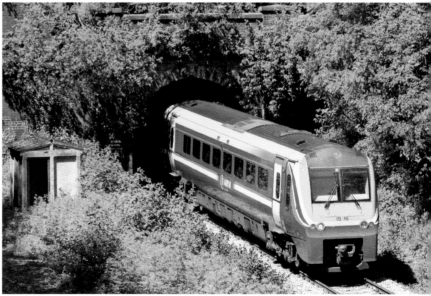

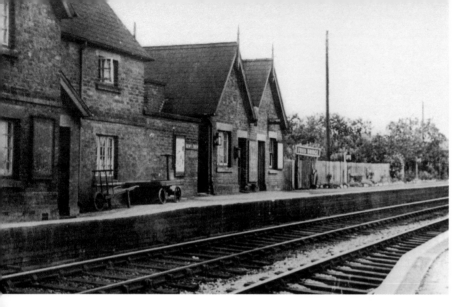

Ford Bridge

Continuing northwards through rural Herefordshire countryside, up trains pass the site of Ford Bridge station. Situated 53½ miles from Newport and a little over 10 miles from Hereford, this wayside stopping place had up and down platforms and a range of attractive, cottage-style station buildings on the up side. The goods yard, also on the up side, could handle coal, livestock, furniture, horseboxes and general merchandise traffic, and there was also a 5-ton yard crane. A minor road crossed the line on the level at the south end of the platforms, while the adjacent signal box was sited on the up side in convenient proximity to the level crossing. The station, known originally as Ford's Bridge, seems to have been opened in the summer of 1854, and it was certainly in existence by 21 October 1854 when, according to *Berrow's Worcester Journal*, a young man's arm became 'dreadfully mangled' when he attempted to rescue a dog that had been running along the platform and got under the 9.40 a.m. train from Hereford.

Opposite: A detailed view of the main station building during the early years of the twentieth century. It is assumed that the single-storey building is being constructed to provide additional office and waiting room accommodation. Ford Bridge station was closed with effect from 5 April 1954.

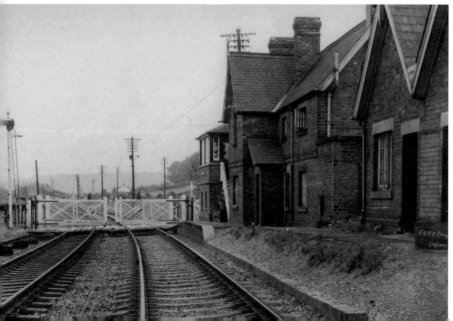

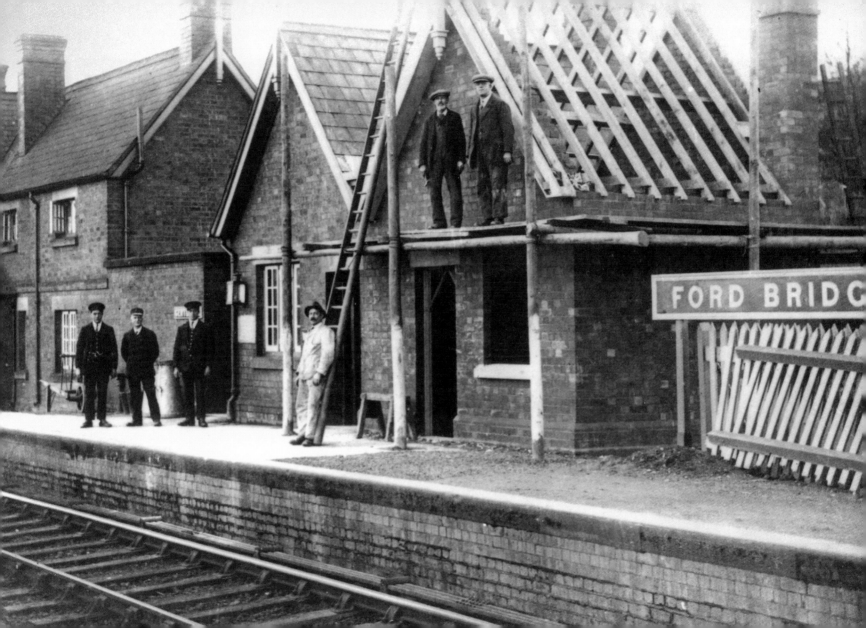

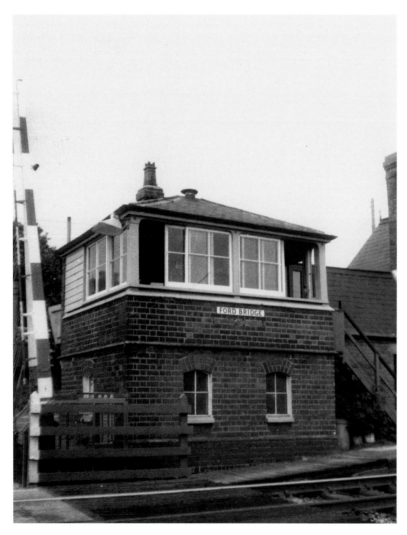

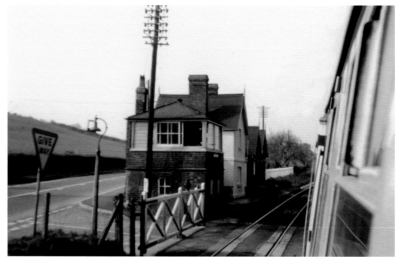

Ford Bridge

Above: A view of Ford Bridge station and signal box taken from a southbound train in 1973. The level crossing was, at that time, still equipped with wooden gates, although these were replaced by lifting barriers in September 1975.

Left: A detailed view of the hip-roofed signal cabin at Ford Bridge, which was similar to other small boxes on the Shrewsbury & Hereford joint line. The box, which contained a 19-lever frame, was closed in October 1988.

Leominster – Change for Bromyard & New Radnor

Running on a more or less dead-level section of track, northbound trains enter much wilder terrain as the railway winds between steep, wooded hillsides on the approaches to Leominster. Situated some 56 miles from Newport, Leominster was a relatively large station, with two island platforms on the east side of the running lines and a side platform to the west, providing five platform faces in all. This lavish infrastructure was needed because Leominster was formerly the junction for branch services to New Radnor and Bromyard. The New Radnor branch was opened as far as Kington on 20 August 1857 and extended to New Radnor on 25 September 1875, while the Bromyard branch was opened in stages and completed throughout between Worcester, Bromyard and Leominster on 1 September 1897. The two branches were worked as separate routes, although in practice a limited number of unadvertised through workings ran between Worcester and New Radnor.

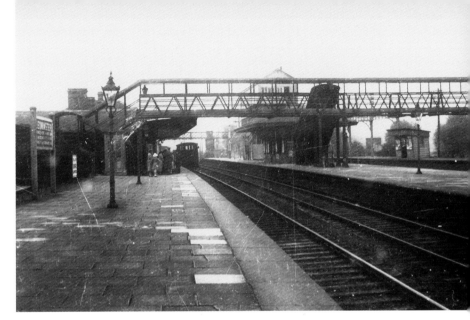

Sadly, the post-war period was a period of decline for these rural lines, and retraction was perhaps inevitable. Passenger services over the New Radnor line were suspended during a coal crisis in 1951, but the service was reinstated as far as Kington after a few weeks, the lightly used section between Kington and New Radnor being closed to passengers. Freight services were cut back to Dolyhir, which thereby became the end of the line from Leominster, while further retraction took place with effect from 7 February 1955 when passenger services between Leominster and Kington were withdrawn, leaving a residual freight service that lasted until September 1964. In the case of the Bromyard line, it became clear that the western end of the route was carrying little traffic, although there would be a continuing need for passenger and freight services between Worcester and Bromyard. It was therefore agreed that the branch would be closed to all traffic beyond Bromyard, and the last trains between Bromyard and Leominster ran on Saturday 13 September 1952. The line was retained as a wagon storage siding for several years, the rails being finally removed around 1958.

The accompanying pictures show Leominster's main up platform, the upper view having been taken around 1930, while the lower view dates from around 1963.

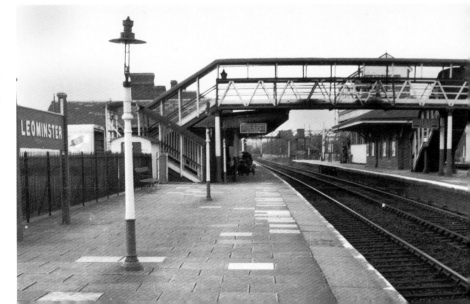

Right: Leominster

This photograph is looking south towards Newport, and it shows the island platforms on down side of the station. The easternmost platform was added in connection with the Bromyard branch, but it saw relatively little use in later years, and the tracks on either side were subsequently removed. Leominster also boasted a two-road engine shed, this facility being sited to the north of the platforms on the down side. The shed was a northlight pattern structure with raised smoke vents, and its usual allocation was about four or five '14XX' class 0-4-2Ts or pannier tanks for duties on the local branch lines. In 1947 the allocation included auto-fitted 0-4-2Ts Nos 1455 and 1460, together with non-auto engines Nos 5807 and 5817, and 0-6-0PT No. 2714. A small turntable was available for use by the branch engines.

Left: Leominster

A detailed view showing part of the main station building on the up side, photographed from the station yard on 11 July 1964. Leominster remains in operation as a staffed station, although only two platforms now remain. The main station buildings have nevertheless survived, while the down platform has been equipped with a waiting shelter of traditional design. The station currently generates around 250,000 passenger journeys per annum.

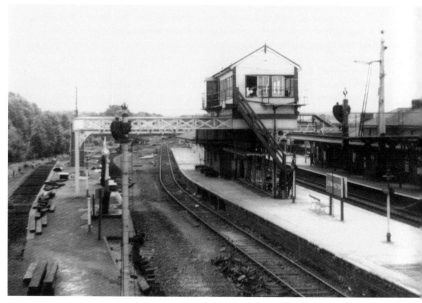

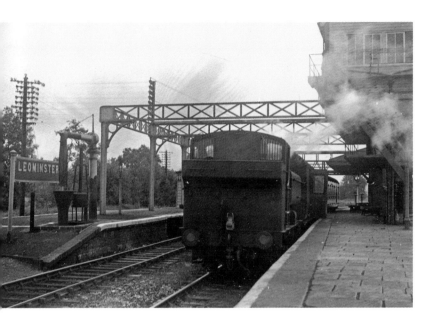

Left: Leominster

An unidentified '57XX' class 0-6-0PT waits at Leominster with a local passenger working.

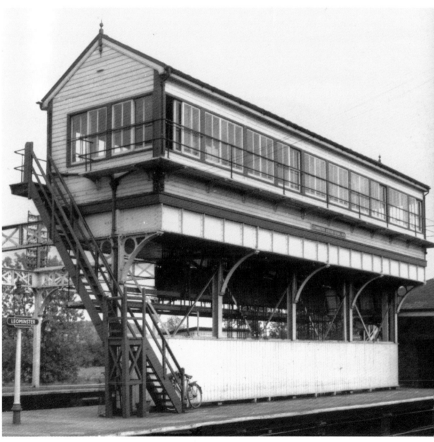

Right: Leominster

The station's most interesting feature was perhaps its raised signal cabin, which was elevated high above the station buildings on the centre island platform. The box, which was of typical London & North Western design, was supported on a system of girders that extended across the up and down running lines, and left the interlocking mechanism in an exposed position for all to see. This unusual cabin contained a 99-lever frame, and it remained in use until May 1964.

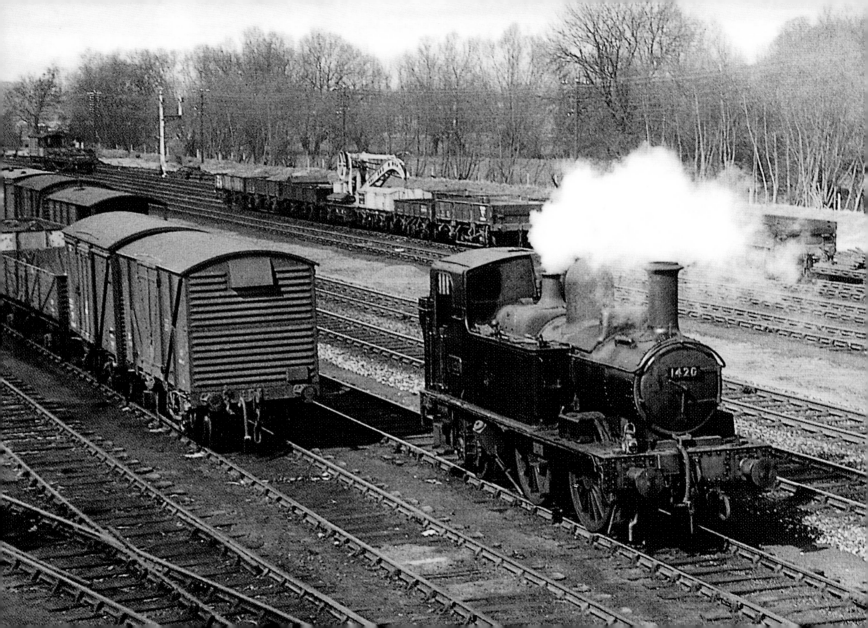

Berrington & Eye

On leaving Leominster, the line maintains its relentless northerly heading as trains pass the site of the closed station at Berrington & Eye (59¼ miles). This station was opened on 6 December 1853 and, in common with many of the other wayside stopping places on the North & West route, it was deleted from the British Railways system with effect from 9 June 1958. The track layout here incorporated staggered up and down platforms, the down platform being somewhat further north than its counterpart on the up side. There was a small goods yard on the down side, while passengers were able to cross the line by means of a stone-built road overbridge, which was linked to the platforms by flights of wooden steps. The picture is looking north towards Chester during the early years of the twentieth century.

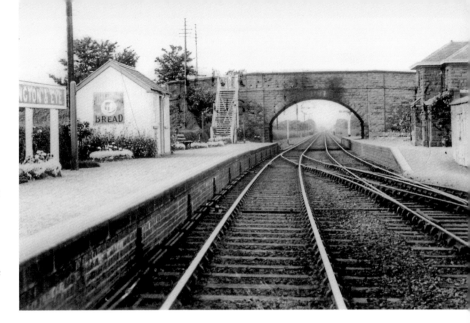

Berrington & Eye

The main station building was on the down side, and there was a wooden waiting shed on the up platform. The main building, seen here after closure, was typical of those provided on the Shrewsbury & Hereford and Shrewsbury & Chester lines insofar as it was an ornate, cottage-style structure that contained domestic accommodation for the stationmaster and his family; the 'house' portion was at right angles to the platform, while the booking office and waiting room was parallel to the track. 'Vernacular' buildings of this same general type are found on many of the lines engineered by Henry Robertson, the implication being that the Shewsbury & Hereford engineer was particularly fond of this design.

Opposite: Leominster

Collett '14XX' class 0-4-2T No. 1420 carries out shunting operations in the sidings at Leominster station in the early 1960s.

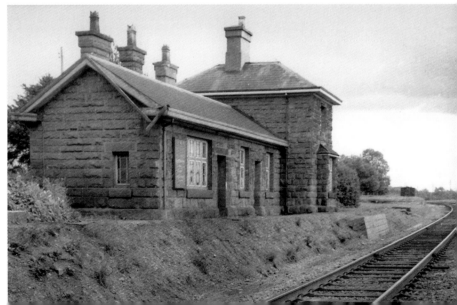

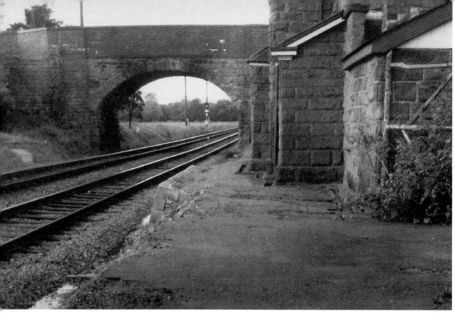

Berrington & Eye

A further view of Berrington station after closure, looking northwards through the arch of the road overbridge with the station building visible to the right; the platforms have been partially removed, although the station building has remained in use as a private house.

Woofferton

From Berrington & Eye, the line runs north-north-eastwards to Woofferton (61¾ miles), the erstwhile junction for branch services to Tenbury Wells and Kidderminster. As trains approach this now closed stopping place, they cross the county boundary between Herefordshire and Shropshire, Woofferton being sited just inside the latter county. The station was opened on 6 December 1853, and it became a junction on 1 August 1861, when the Tenbury Railway was opened between Woofferton and Tenbury Wells – a distance of 5 miles 9 chains. As a modest branch line serving the needs of a prosperous farming district, the Tenbury line's future seemed secure, but there were demands for still more railways in the area, and on 3 July 1860 powers were obtained for a 15-mile extension from Tenbury to Bewdley, where connection would be made with the Severn Valley Railway. The Tenbury & Bewdley Railway was opened on 13 August 1864, and the Tenbury Railway and the T&BR thereby formed a continuous 20-mile route between Woofferton in the west and Bewdley in the east.

The Tenbury line was worked by the GWR, and trains usually ran through from Hereford or Woofferton to either Stourbridge Junction or Kidderminster, although there were also a number of local services between Woofferton and Tenbury Wells. Goods trains ran from Stourbridge Junction to Hereford, and separate goods workings returned to Hereford or Kidderminster later in the day as part of a complex pattern of operation involving two or more engines.

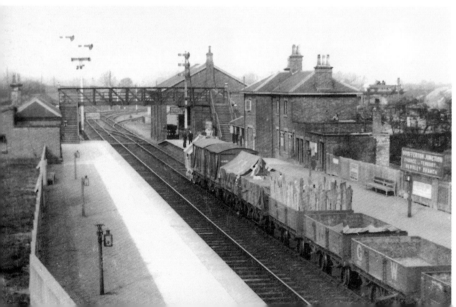

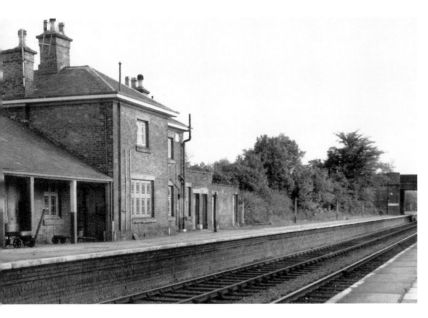

Right: Wooferton – The Main Station Building

A further view of the main station building, looking north towards Shrewsbury during the early 1960s. The brick-built goods shed was sited just beyond the platform on the down side, while the signal box can be discerned in the distance. The Tenbury Wells line diverged westwards from a junction situated between the goods shed and the signal box.

Left: Woofferton – The Main Station Building

Woofferton's main station building was situated on the down platform. As usual on the North & West route, this brick-built structure included a stationmaster's house, in addition to the booking office and waiting room; the 'house' portion was a substantial two-storey block with distinctive small, paned windows, whereas the waiting room and toilets were housed in single-storey wings. The up and down sides of the station were linked by an open girder footbridge, while a much smaller hip-roofed building on the up platform provided additional toilet and waiting room facilities.

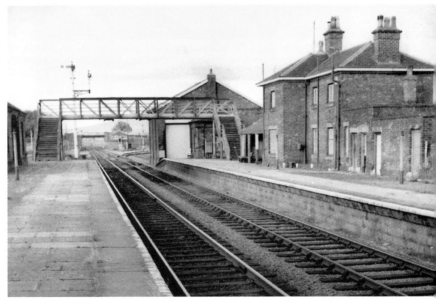

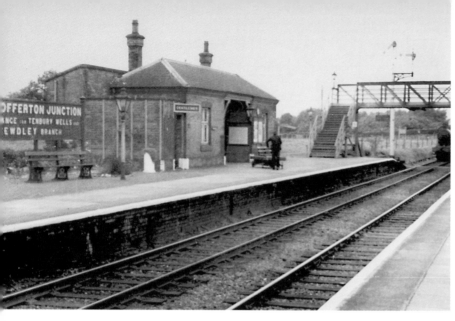

Woofferton – The Up Side Building

A glimpse of the up side station building, which was of similar design to the main building on the down platform. A bay platform was available at the north of the up platform, but Tenbury Wells branch services also used the main platforms. The nameboard proclaims, 'WOOFFERTON JUNCTION – CHANGE for TENBURY WELLS and BEWDLEY BRANCH'.

Woofferton – The Branch Platform

A detailed view showing a Tenbury Wells branch train in the bay platform, probably during the late 1940s. The locomotive is '45XX' class 2-6-2T No. 4586. The Tenbury and Bewdley branch was never a particularly remunerative route, this problem being compounded by accounting methods that treated local branch lines in isolation from the main line system and thereby ignored the 'network effect'. It was impossible to adequately calculate the true value of these lines to the railway system, although the cost of operating and maintaining them was only too obvious. It therefore came as no surprise when, in the early 1960s, it was announced that all services would be withdrawn between Woofferton and Tenbury with effect from 31 July 1961. As this was a Monday, the last scheduled passenger trains ran on Saturday 29 July 1961, on which day Woofferton station was also closed to passengers.

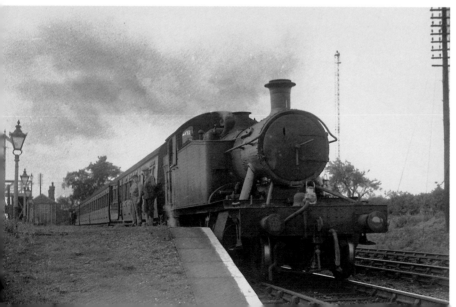

Woofferton

Right: Having traversed the Central Wales line and reversed at Craven Arms, class '37' locomotives Nos 37174 and 37375 pass Woofferton with the diverted 3.39 a.m. Margam to Llanwern steel empties on 28 May 2000, the extremely circuitous journey having been necessary because of weekend engineering works at Bridgend.

Below left: Class '60' locomotive No. 60023 passes Woofferton on 6 November 1999 with the 9.02 a.m. Dee Marsh to Llanwern steel empties on 6 November 1999.

Below right: A post-closure view of Woofferton station, looking northwards along the branch bay platform.

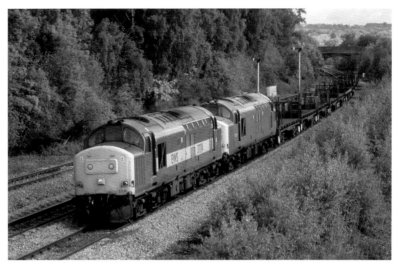

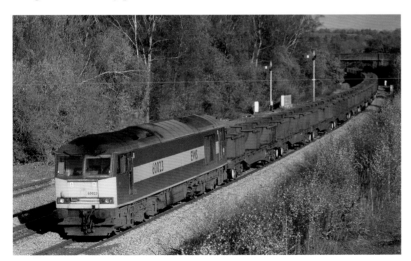

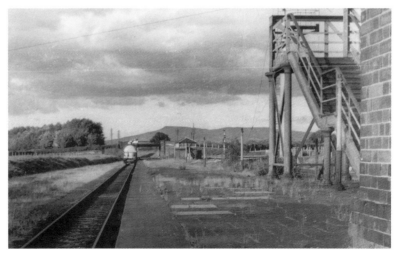

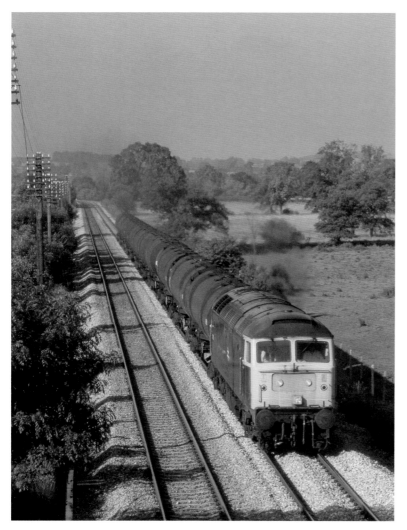

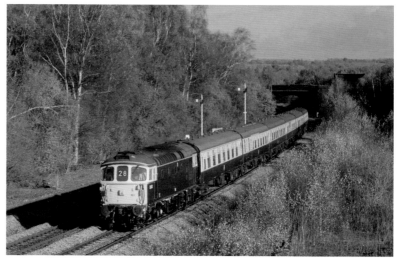

Woofferton – Trains on the Line

Above: Class '33' locomotive No. 33103 heads southwards through a colourful autumnal landscape at Woofferton with the 8.35 a.m. Crewe to Cardiff Rugby World Cup special on 6 November 1999. The match, held in the Millennium Stadium, was between Australia and France – the result was a 23 point victory for the Australians.

Left: Traditional telegraph poles are still much in evidence beside the North & West route at Orleton, near Woofferton, as class '47' locomotive No. 47362 heads northwards with the 2.40 p.m. Waterston to Albion Gulf oil tanks on 18 June 1984. This picture was taken from Tunnel Lane, which derives its name from the nearby Leominster Canal Tunnel.

Ludlow

Ludlow (67 miles), a popular tourist centre, is famous for its medieval castle and picturesque timber-framed houses. The station, opened on 21 April 1852, is built on a sweeping 'S'-curve at the mouth of a short tunnel, and its two side platforms are linked by an unusual brick and lattice girder footbridge. The upper photograph, taken on 11 July 1964, shows the main station buildings on the up side, which were similar to those found elsewhere on the Shrewsbury & Hereford route. As usual, they exhibited late-medieval 'Tudor' Gothic features, the main block being a two-storey structure, with steeply pitched roofs and romantic, clustered chimney stacks. The windows were mullioned and transomed, and the platform frontage was protected by a canopy edged with typical Victorian fretwork decoration. The canopy, which detracted from the otherwise strictly 'Tudoresque' appearance, may well have been a later addition. The lower view is looking northwards along the up platform during the 1960s, shortly before the Victorian station building was demolished.

Ludlow handled around 62,000 passengers per annum during the early 1900s. In 1903, for example, the booking office issued 63,735 tickets, rising to 60,518 in 1913 and 62,220 by 1923. In the latter year, there were also 105 season ticket sales, each season ticket being the equivalent of perhaps thirty ordinary ticket sales. In 1930, the station issued 43,401 tickets, while in 1935 and 1938 the corresponding figures were 30,632 and 22,725 respectively.

Freight traffic amounted to 221,224 tons in 1903, much of this traffic being in the form of minerals from the nearby Clee Hill quarries. By 1913, the station was handling almost 270,000 tons of freight per annum, though by 1930 this figure had dropped to 162,679 tons, of which 140,042 tons was described 'other minerals'. In that same year, Ludlow dealt with 1,319 wagon loads of livestock and 3,073 tons of 'carted traffic'.

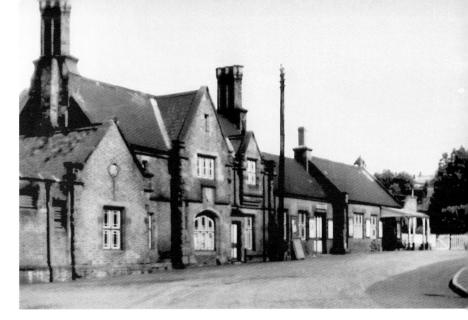

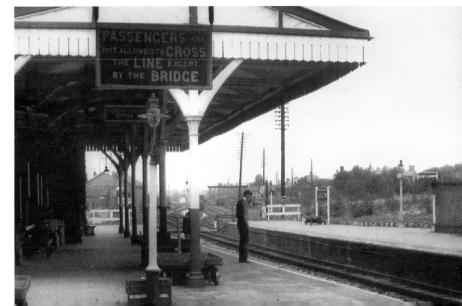

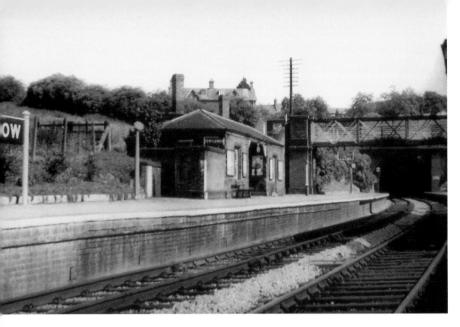

Ludlow

The down side building was a single-storey, hipped roof structure with a recessed centre loggia. Internally, it provided additional waiting room accommodation for travellers waiting on the southbound platform, while a gentlemen's urinal was housed in a small extension to the left of the main block (when viewed from the platform). This small structure was very similar to the down side waiting room block at Woofferton, suggesting that both buildings had been erected at the same time from the same set of plans. Following rationalisation during the 1960, simple 'bus-stop'-type waiting shelters replaced the main station buildings on the up side, but these have now been replaced by more substantial shelters and a new, purpose-built booking office.

Ludlow

A general view looking northwards from a vantage point above the tunnel mouth. The goods shed that can be seen in the distance was of conventional design and appearance. It was solidly constructed, with a gable roof and an internal loading platform, together with a lean-to office at the south end. Large doorways in the north and south gables enabled railway vehicles to be shunted into the building for loading or unloading purposes, while a similar entrance in the west wall enabled road vehicles to be backed-up to the internal loading bay.

In staffing terms, Ludlow station provided employment for around forty people, including passenger clerks, goods clerks, porters, signalmen, foremen, checkers and delivery drivers. In 1929, for instance, the staff establishment consisted of thirty-nine employees, whereas in 1938 there were forty station and goods yard staff. Ludlow-based road vehicles provided free collection and delivery services for traders and resident within the town itself, while GWR country lorries served surrounding villages and hamlets such as Knowbury (7 miles from the station) and Doddington (8 miles).

Opposite: Ludlow

With the town of Ludlow visible in the background, Class '37' locomotive No. 37412 *Driver John Elliot* heads northwards with the 1.05 p.m. Cardiff Central to Liverpool Lime Street Regional Railways service on 20 August 1995.

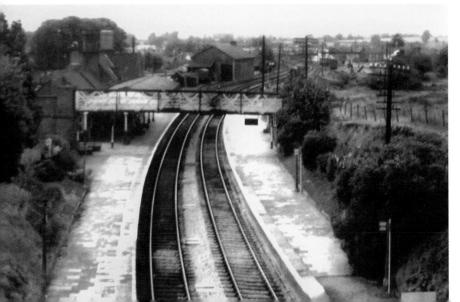

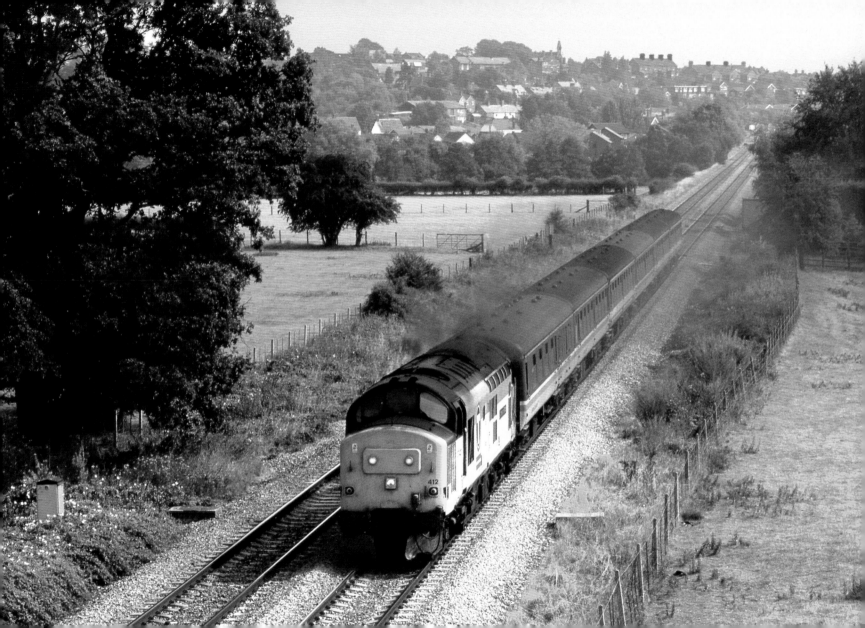

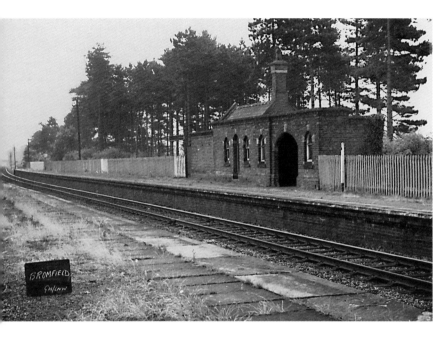

Left: Bromfield

From Ludlow, the railway climbs north-westwards through increasingly wild scenery, keeping close company with the A49 road and the little Onny River. Bromfield station (69¼ miles), was opened on 21 April 1852 and it served the adjacent Ludlow Racecourse. In its heyday, Bromfield had been a fully equipped station with a range of facilities for all forms of traffic. The 1938 Railway Clearing House *Handbook of Stations* reveals that the station was able to deal with coal, minerals, livestock, horses, furniture, machinery, vehicles and general merchandise traffic. A 5-ton yard crane was available for use when timber or other heavy or bulky consignments were sent by goods train, and a special platform was available for dealing with horseboxes. Although regular passenger services were withdrawn with effect from 9 June 1958, Bromfield station remained in use for race traffic for several years thereafter.

Right: Onibury

Onibury (71½ miles), a little over 2 miles further on, was opened on 21 April 1852 and, like so many other stations on this section of the line, it became a victim of the June 1958 closure programme. This Edwardian postcard view is looking north towards Chester, the main station building being visible to the right, while the level crossing and signal box can be discerned in the distance; the goods yard was situated at the rear of the down platform. The timber footbridge was later replaced by a lattice girder structure.

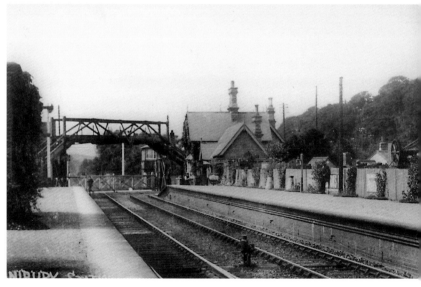

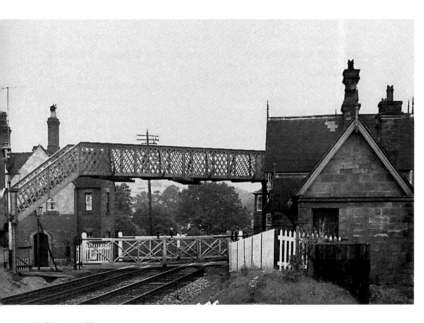

Left: **Onibury**
A later view of the station, dating from around 1963. By this time the platforms had been removed, although the station building and other Victorian infrastructure was still intact.

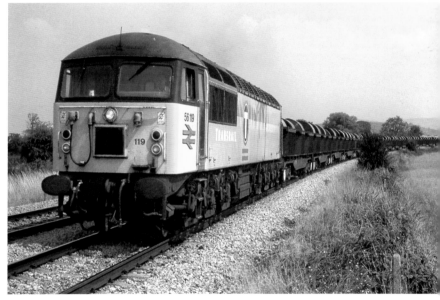

Right: **Onibury**
Class '56' locomotive No. 56119 approaches Onibury with the 11.38 a.m. Llanwern to Dee Marsh steel coils train on 20 August 1995. This working was one of two northbound steel trains that ran over the North & West line on Sundays during the 1990s, the other being the 10.56 a.m. Margam to Dee Marsh service, which was usually hauled by a class '60' locomotive and would have passed this spot approximately 2 hours later.

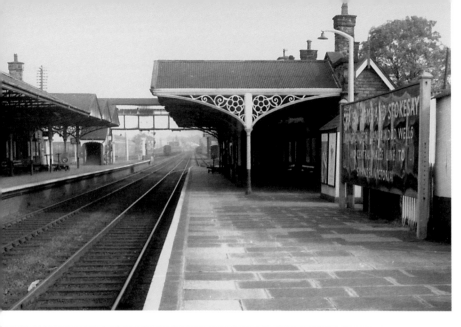

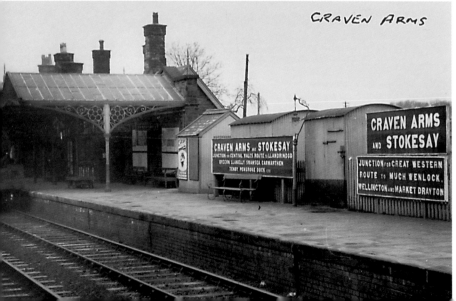

Craven Arms & Stokesay – Origins of the Central Wales & Wenlock Lines

As they approach Craven Arms (74½ miles), northbound trains pass within yards of Stokesay Castle – a perfect example of a fifteenth-century moated manor house. Craven Arms station was opened on 21 April 1852 and it became a junction when the first section of the Central Wales route was opened on 1 October 1860. When completed throughout on 8 October 1868, the Central Wales line furnished the London & North Western Railway with its own line to South Wales. Meanwhile, further to the east, the Much Wenlock & Severn Junction line was opened between Buildwas and Much Wenlock on 1 February 1862, while on 22 July 1861 the Much Wenlock, Craven Arms & Coalbrookdale Railway had been incorporated by Act of Parliament with powers for extensions of the original Wenlock line from Buildwas to Coalbrookdale and from Much Wenlock to Craven Arms. The Coalbrookdale line was brought into use on 1 November 1864, and the Craven Arms line was ready for opening as far as Presthope on 5 December 1865. The southernmost section between Presthope and Marsh Farm Junction, near Craven Arms, was finally completed on 16 December, and a 28-mile cross-country link was thereby brought into use between Craven Arms, Much Wenlock and Wellington.

The Central Wales line was listed for closure in the Beeching Report, although in the event the line was reprieved. Sadly, a somewhat different situation pertained in the case of the Wenlock branch, which had never carried much passenger or freight traffic. Inevitably, the southern portion of the line from Wellington became an early victim of rationalisation, and in September 1951 passenger services were withdrawn between Much Wenlock and Craven Arms (exclusive). In practice, this deletion made little difference to the pattern of operations at Craven Arms, which was historically more important as the junction for the still-extant Central Wales line.

The accompanying photographs show the main platforms – the upper view is looking northwards along the down platform around 1963, while the lower view shows an impressive array of name-boards on the down platform.

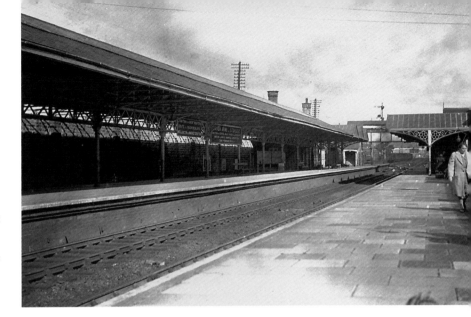

Craven Arms & Stokesay

Prior to rationalisation, Craven Arms had boasted a fairly complicated track layout, providing a multiplicity of loops and sidings. Four platform faces were available, the up platform being equipped with terminal bays at each end. The photograph, taken around 1949, shows the Central Wales bay at the south end of the platform, which was covered for much of its length by a substantial canopy. The up and down platforms were linked by a covered footbridge, and there were extensive glass and iron canopies on both sides.

Craven Arms & Stokesay

A view of the up platform during the early 1960s, by which time the canopy over the Central Wales bay had been partially demolished. The main station building was on the down side, and this substantial structure contained a booking office, waiting rooms and toilets, together with a stationmaster's house. The front of the building was protected by a ridge-and-furrow canopy with elaborate cast iron columns, while the up platform was equipped with a waiting room and a much shorter section of ridge-and-furrow canopy.

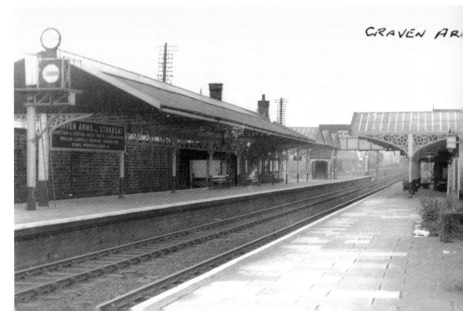

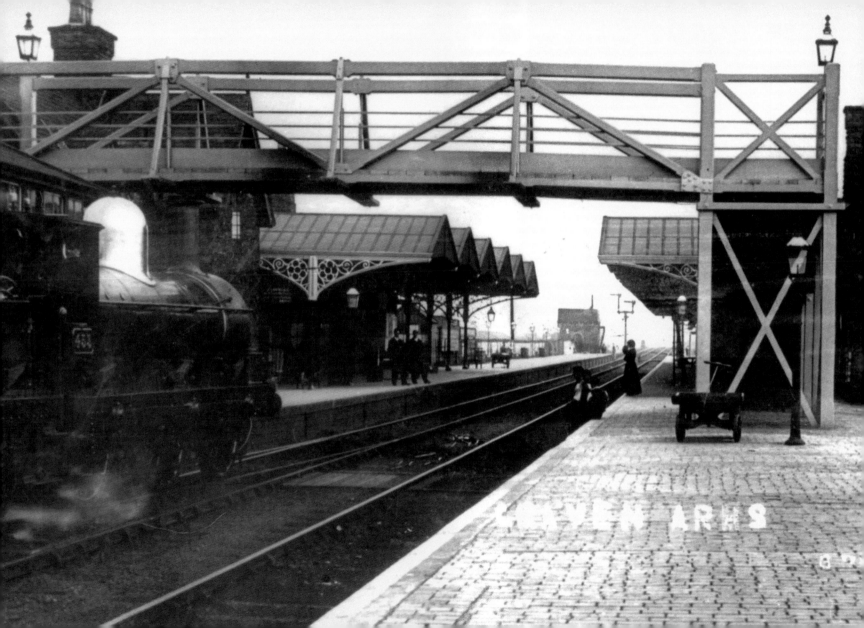

CRAVEN ARMS

Craven Arms & Stokesay

Right: A general view, looking southwards along the down platform during the early 1960s. Like Ludlow, Craven Arms lost its Victorian station buildings during the 1960s, but a running loop and several sidings were retained for goods traffic.

Below left: 'Bulldog' class 4-4-0 No. 3403 *Trinidad* waits in the down platform with a southbound passenger train. This locomotive was built at Swindon works in March 1904, and it remained in service until January 1937.

Below right: Great Western steam railmotor car No. 74 stands in the up platform with a Much Wenlock branch working during the early years of the twentieth century.

Opposite: A view of the station during the early years of the twentieth century.

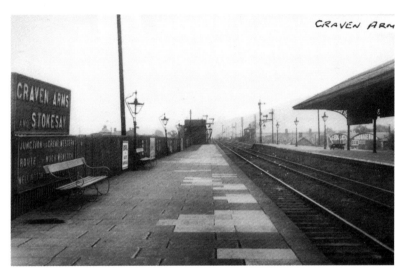

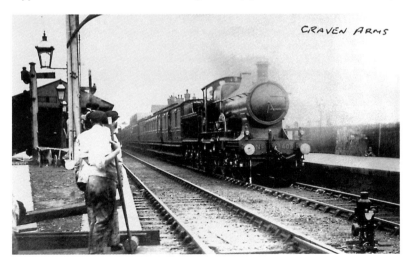

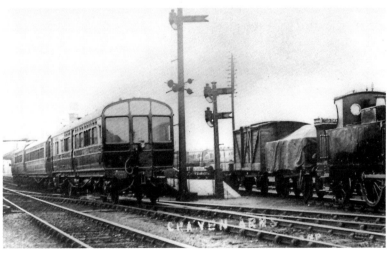

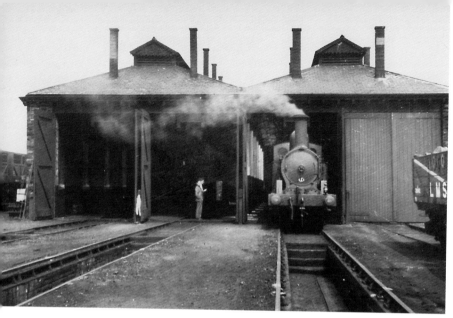

Craven Arms & Stokesay – The Engine Shed

Above: Craven Arms was also the site of a London & North Western Railway engine shed, the latter facility being sited to the north of the passenger station on the up side of the running lines. The shed building was a four-road structure with a hipped roof, while the usual coaling stage and turntable were provided. This 1930s view shows a former London & North Western tank locomotive on one of the shed roads. A six-road carriage shed was sited a short distance to the north of the engine shed.

Below: A later view of the engine shed during the British Railways era around 1962, by which time the number of shed roads had been reduced from four to three. A Stanier 'Black Five' 4-6-0 can be seen to the right. With the Cold War at its height, the nearby carriage shed was, at that time, being used to store an emergency communications train, which would have been employed as a mobile communications centre in the event of a nuclear attack or other major national emergency.

Opposite: Craven Arms & Stokesay

Ex Great Western '44XX' class 2-6-2T No. 4403 waits in the down platform with a Much Wenlock branch train around 1951. The original portion of the main station building can be seen to the left of the picture.

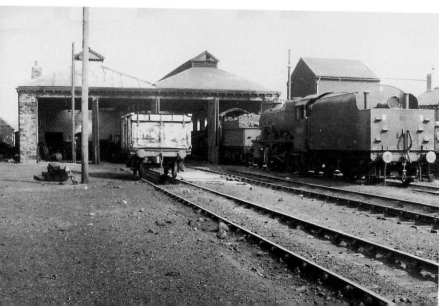

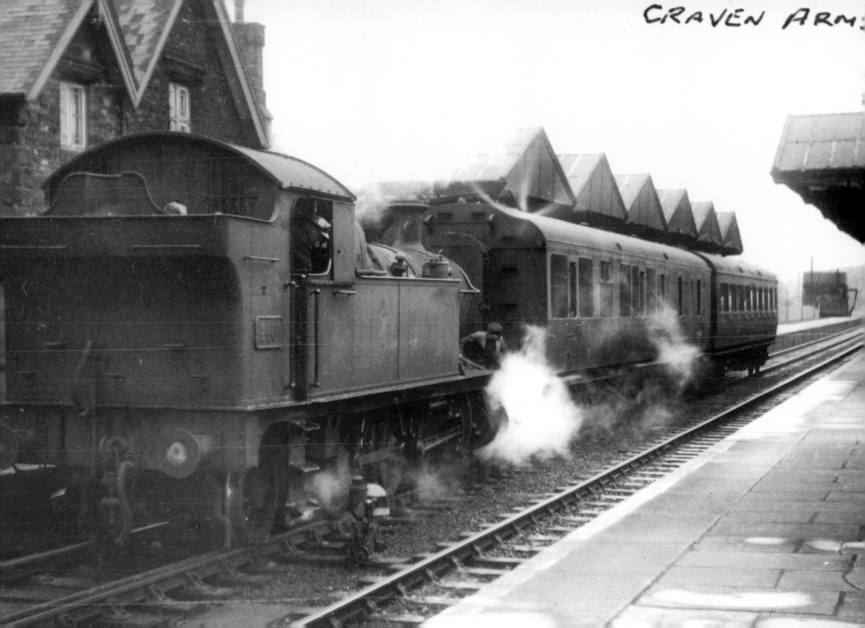

CRAVEN ARMS

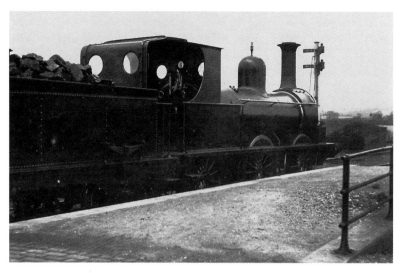

Craven Arms & Stokesay – The Bishop's Castle Railway

Craven Arms was the starting point for the archaic and eccentric Bishop's Castle Railway, which was incorporated on 28 June 1861 and opened for public traffic between Craven Arms, Lydham Heath and Bishop's Castle on 1 February 1866. From its inception, the company was faced with serious financial difficulties, the situation being worsened by the failure of bankers Overend, Gurney & Co. in May 1866, which plunged the Victorian banking system into chaos. Having refused to merge their ramshackle undertaking with the GWR or other main line companies, the supporters of the BCR managed to eke out an impecunious existence for many years before finally closing with effect from Saturday 20 April 1935. *Left*: The veteran Kitson 0-6-0 tender locomotive *Carlisle*, which worked on the BCR for many years, stands in the Bishop's Castle bay platform at Craven Arms.

Below left: BCR 0-4-2T No. 16 at Plowden, on the Bishop's Castle line. This '517' class locomotive was purchased second-hand from the GWR.

Bottom right: The BCR diverged from the North & West route at Stretford Bridge Junction, about ¼ mile to the north of Craven Arms.

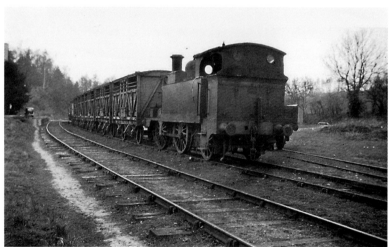

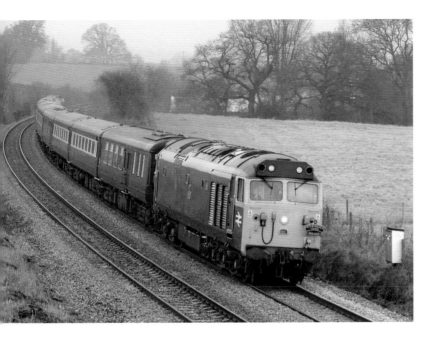

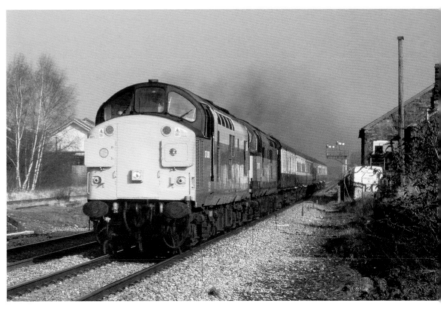

Left: **Craven Arms & Stokesay**
Class '50' locomotive No. 50031 *Hood* rounds the curve at Cheney Longville, on the approaches to Craven Arms, with the 11.05 a.m. Pathfinder Tours 'Christmas Diner' railtour on 16 December 2003. This working, which ran from Gloucester to Worcester via Shrewsbury and Hereford, was hardly a railtour in the normal sense of the term as it had no intermediate stops – as the name suggests, it was purely a chance to enjoy a meal and watch the scenery go by!

Right: **Craven Arms & Stokesay**
Class '37' locomotives Nos 37038 and 37197 storm southwards through Craven Arms with the 8.05 a.m. Crewe to Cardiff Central rugby special on 22 March 2003. The substantial, stone-built goods shed can be seen to the right of the picture while, to the left, the former carriage shed is partially hidden behind a tree.

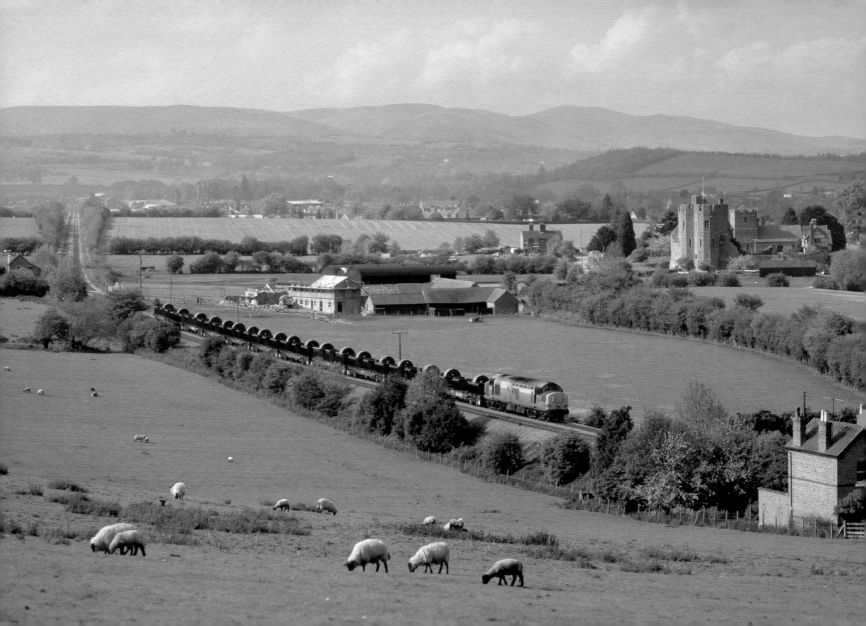

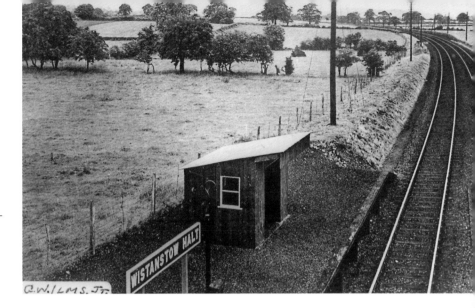

Wistanstow Halt

Above: On departing from Craven Arms, up workings head north-north-eastwards to the site of Wistanstow Halt (76 miles), an unstaffed stopping place that was opened on 7 May 1934 and closed with effect from 11 June 1956. Marsh Farm Junction was only a short distance further on.

Below: Class '37' locomotive No. 37197 passes Wistanstow with the 9.50 a.m. Crewe to Cardiff Central rugby special on 25 May 2002. The engine is carrying the strange Riley & Sons livery, which blends in with the late spring green foliage.

Opposite: Craven Arms & Stokesay

Class '37' locomotive No. 37207 passes the thirteenth-century Stokesay Castle with the 10.38 a.m. Margam to Llanwern steel train on 27 May 1996. Due to engineering work in South Wales, this working had been diverted via the Central Wales line, necessitating a reversal at Craven Arms.

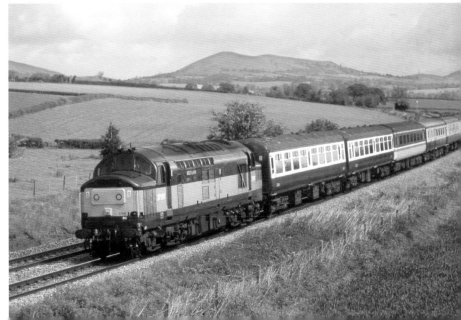

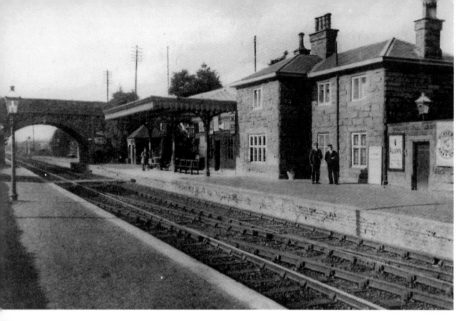

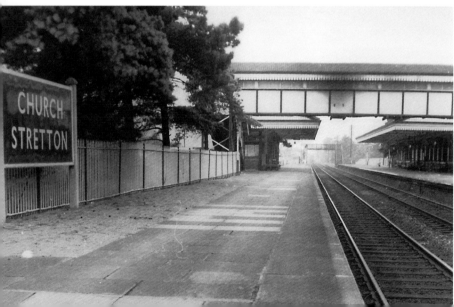

Church Stretton

Continuing northwards through beautiful Shropshire countryside, trains pass through a narrow gorge, with Caer Caradoc on the right, and the 1,695 foot mass of the Long Mynd towering high above the left-hand side of the line. Following this natural geological feature, the railway climbs towards its 400-foot summit near Church Stretton on ascending gradients of 1 in 90 and 1 in 100.

Church Stretton (81½ miles) is dramatically situated amid heather-clad heights, which give this part of the railway the atmosphere of a 'true' mountain line. Now an unstaffed halt with modern waiting shelters, Church Stretton once boasted a comparatively complex track layout. The upper picture, dating from around 1908, shows the original station building, together with the road overbridge which carried the present B4371 road across the line. In 1914, a new station was opened on the south side of the bridge, the replacement station being shown in the lower photograph. The goods yard on the up side contained an array of parallel sidings, one of which served a small brick goods shed. Other sidings were used for coal traffic, and there were also cattle pens and loading banks for vehicles or machinery; the yard crane was of 2 tons 10 cwt capacity. An additional siding on the down side served as a goods refuge siding. The signal box, also on the down side, was a diminutive, hipped-roof signal structure.

It is interesting to note that the original Shrewsbury & Hereford station building can still be seen on the far side of the bridge; this picturesque stone-built structure was sited on the up side of the line, just a few chains to the north of the present-day station. Like other stations en route to Shrewsbury, Church Stretton served a comparatively small rural area that extended for no more than about half-a-dozen miles on either side of the railway. Church Stretton itself was within the station's 'free cartage' area, while a GWR country lorry service was available for traders and farmers living in nearby villages such as Ratlinghope (6 miles from the station) and Hope Bowdler (2 miles).

Leebotwood and Condover

The summit of the Shrewsbury & Hereford line is situated a little to the south of Church Stretton, and having left that station northbound trains are able to coast downhill towards Shrewsbury on 12 miles of favourable gradients, with much of the descent being on a falling gradient of 1 in 100. Passing the site of an abandoned halt at All Stretton, up workings soon reach Leebotwood (85 miles). This small station, closed in 1958, had been similar to the other intermediate stopping places on the Shrewsbury & Hereford line, with the usual range of accommodation for passengers, freight and livestock traffic.

Beyond, the railway descends steadily towards yet another closed station at Dorrington (88 miles). Until its closure in 1958, Dorrington had featured up and down platforms, with a brick station building that incorporated a two-storey house for the stationmaster and his family. The goods yard contained coal wharves, cattle pens and an end-loading dock for vehicular traffic, while the signal cabin was another hipped-roof L&NWR type structure. Rushing past the remains of this long-closed station, trains drop below the level of the 300-foot contour as they continue their descent towards Shrewsbury. The upper picture shows the site of Leebotwood station, and the lower view is a post-closure view of neighbouring Condover station.

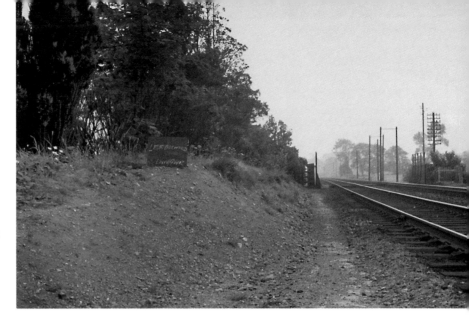

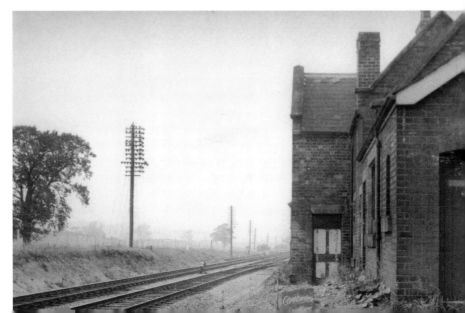

Condover

Above: Class '47' locomotive No. 47442 rounds the curve at Bayston Hill, near Condover, on 3 July 1985, with the 7.05 a.m. Holyhead to Cardiff Central service. The train has just passed the ground frame controlling access to the rail-linked quarry that can be seen in the background. At this time the rail connection was still in regular use.

Below: Metro-Cammell class '101' set C803, comprising motor brake second No. 51450 and motor composite No. 51522, passes Bayston Hill while working the 5.40 a.m. Swansea to Shrewsbury service on 3 July 1985. The train is nearing the end of its mammoth 3½-hour journey via the Central Wales Line. Set C803 was originally a 3-car unit, but having lost its centre coach (trailer composite No. 59546), this class '101' set survived as a two-car unit for another four years before making way for the new generation of 'Sprinter' units.

Opposite: Condover

Class '47' locomotive No. 47792 *Saint Cuthbert* rounds the curve at Bayston Hill while hauling the 9.40 a.m. Liverpool to Cardiff 'Northern Belle' on 25 February 2001. This working was carrying rugby fans to a match in Cardiff.

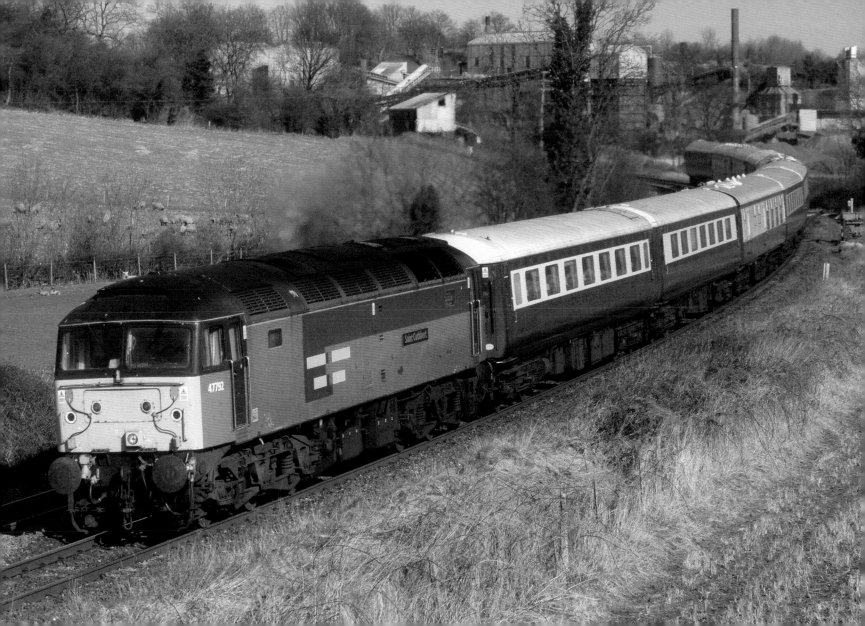

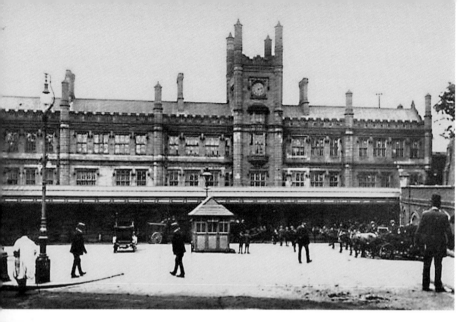

Shrewsbury – The Main Station Buildings

From Condover, northbound workings rapidly approach Shrewsbury (94¼ miles), the northernmost station on the Shrewsbury & Hereford line, and the starting point for the Shrewsbury & Chester section. Still a nodal point at the junction of several cross-country routes, Shrewsbury is the largest intermediate station on the North & West route, and it was formerly the headquarters of London & North Western and Great Western Joint lines.

The station is, with Hereford, one of the finest examples of 'railway Gothic' architecture in these islands. The main block, designed by Thomas Penson, is of three stories, with a clock tower and mullioned and transomed windows. The station was first opened on 14 October 1848, though considerable enlargement took place in 1855 and there was a major reconstruction at the end of the Victorian period, when the cellars beneath Penson's original building were opened out and adapted for use as a booking office and other accommodation. A new entrance and subway were provided as part of the rebuilding scheme. There was, at one time, a cavernous overall roof, but this has long since been removed, resulting in a more spacious and much less claustrophobic atmosphere.

The upper view, from a contemporary postcard, shows the main façade around 1912, while the lower photograph illustrates the opposite side of the building during the early 1960s. The pedestrian footbridge that can be seen in the background carries a public footpath across the railway; the bridge is known locally as 'The Dana', presumably because it led to the now-closed Shrewsbury Prison, which was built on the site of a medieval prison known as the Dana Gaol.

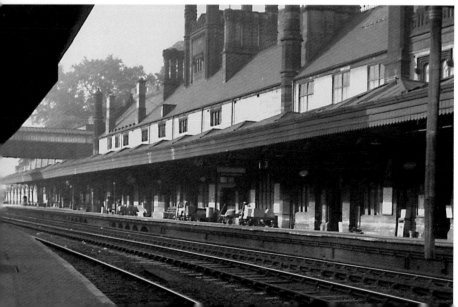

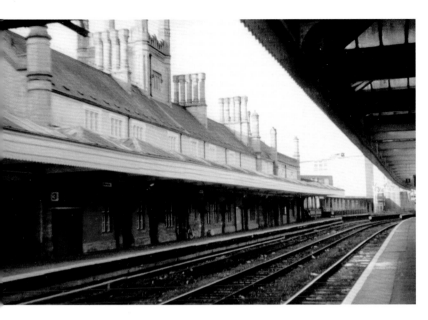

Left: **Shrewsbury**

Until 1954, the platforms had been numbered from 1 to 10, but they have latterly been numbered from 1 to 7. The operational side of the station has three long through platforms, which are numbered 3, 4 and 7, and four terminal bays, the latter being designated platforms 1, 2, 5 and 6. Main line services use platforms 3, 4 and 7, platform 3 having recently been brought back into regular use after a period in which it was used mainly for parcels traffic and football specials. Platforms 5 and 6, at the south end of the main island platform, are used by terminating services from the Aberystwyth and Central Wales lines, but Platforms 1 and 2, at the south end of Platform 3, which in recent years were used mainly for storage purposes, have now lost their trackwork. The photograph shows Platform 3, which is long enough to accommodate thirteen bogie coaches.

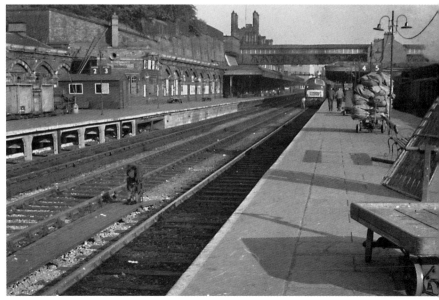

Right: **Shrewsbury**

A general view of the station, looking northwards along Platform 4 during the early 1960s. Platform 4 is 1,013 feet in length, while Platform 3, visible to the left, has a length of 1,188 feet. The station area was formerly worked from three signal cabins, which were known as Severn Bridge Junction Box, Shrewsbury Central Box and Crewe Junction Box. The Central Box, which had been situated in an elevated position above bay Platforms 5 and 6, was abolished in 1961, and the station was then signalled from the remaining Crewe Junction and Severn Bridge Junction cabins. Both of these signal boxes are of standard L&NWR design, Severn Bridge Junction Box being an enormous structure with a 192-lever frame; this giant box was erected in 1902. Other signal cabins were located at Abbey Foregate, English Bridge Junction (closed in 1955) and Sutton Bridge Junction.

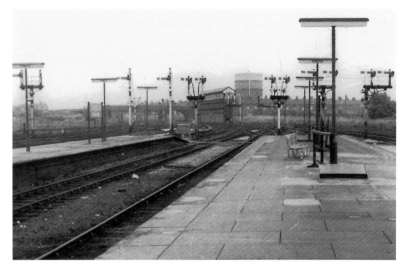

Shrewsbury – General Views

Left: This *c.* 1960s view is looking southwards along bay Platforms 5 and 6. Severn Bridge Junction Signal Box can be seen in the distance.

Below left: A view northwards along Platforms 5 and 6, taken around 1980.

Below right: Sutton Bridge Junction Signal Box, on the outskirts of Shrewsbury, pictured on 2 September 2000. This standard Great Western hipped roof box controls the routes to Hereford and Aberystwyth, the points in the foreground forming a facing crossover that enables trains bound for central Wales to gain access to the single line.

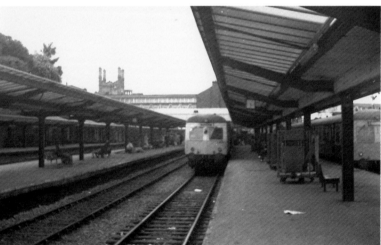

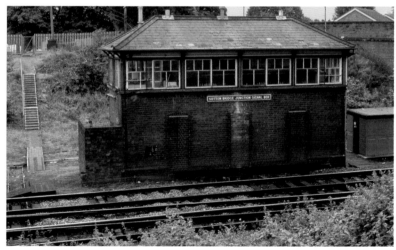

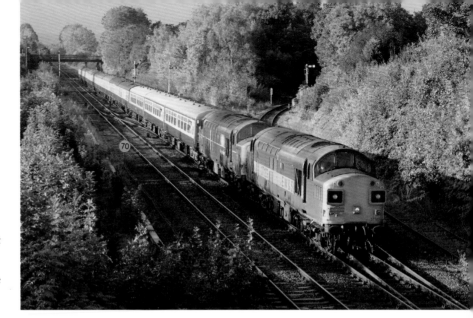

Shrewsbury – Sutton Bridge Junction

Class '37' locomotives Nos 37109 and 37047 pass Sutton Bridge Junction with the 6.22 a.m. Pathfinder Tours Bristol Temple Meads to Carlisle 'Settle & Carlisle Railway' railtour on 2 October 2004. The joint Great Western–London & North Western line to Welshpool can be seen disappearing into the bushes at the rear of the train. This is in effect the start of the present-day Cambrian route; the original Cambrian main line between Whitchurch, Oswestry and Welshpool was closed in 1964.

Shrewsbury – Some Tickets

A selection of a GWR and British Railways tickets from the Newport to Shrewsbury section of the North & West route. The examples shown here include two platform tickets, the Hereford ticket being a paper issue, while the Shrewsbury platform ticket is a standard Edmondson card. Great Western third-class tickets were a darker shade of green that their British Railways counterparts – third class was officially replaced by 'second class' on Sunday 3 June 1956, although there was no difference in the accommodation provided or the fares that were charged!

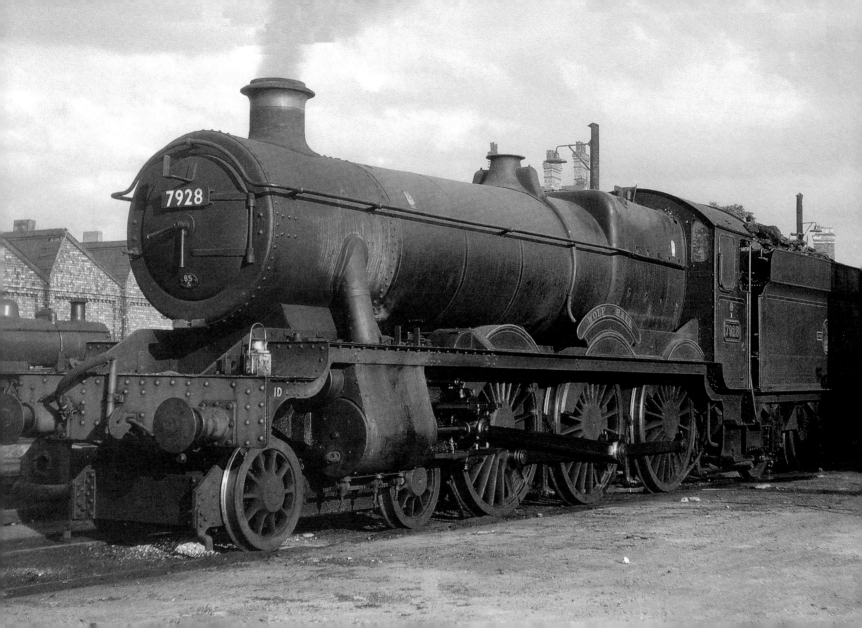

Leaton

Leaving Shrewsbury, the double-track Shrewbury & Chester route commences a 1½-mile climb on a rising gradient of 1 in 100, after which the route levels out on the approaches to Leaton (98 miles). Opened by the S&CR on 14 October 1848, Leaton was merely a wayside station serving a scattered agricultural community. Its track layout comprised up and down platforms and a small goods yard, the main station building being on the down side of the running lines, while a level crossing was sited at the south end of the platforms. The goods yard handled mainly coal and other wagonload consignments, although there was also a cattle pen for livestock traffic.

Leaton was closed to passengers with effect from 12 September 1960, and the accompanying photographs date from the post-closure period. The upper view is looking northwards along the down platform, while the lower photograph was taken from the up platform ramp. The bay window that can be seen on the extreme right is part of the original 1848 station building, which contained domestic accommodation for the stationmaster and his family. The standard GWR hipped roof station building on the up platform was a later addition, which, from its appearance, was probably added towards the end of the nineteenth century. As a footnote, it should be explained that having left Newport as 'up' workings, North & West trains become 'down' services when they reach Shrewsbury, northbound workings being regarded as 'down' trains on the Shrewsbury & Chester section.

Opposite: **Shrewsbury**

During steam days, Shrewsbury motive power depot (84G) housed an assortment of 'Castles', 'Halls', panniers, prairie tanks and '43XX' class 2-6-0s, together with various ex-LMS classes including 'Black Five' and 'Jubilee' class 4-6-0s. The photograph, from a 35 mm colour slide taken by John M. Strange, shows 'Modified Hall' class 4-6-0 No. 7928 *Wolf Hall* at Shrewsbury shed in 1964.

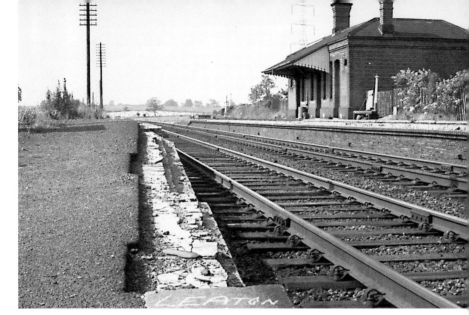

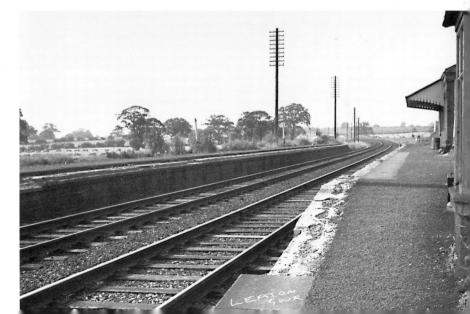

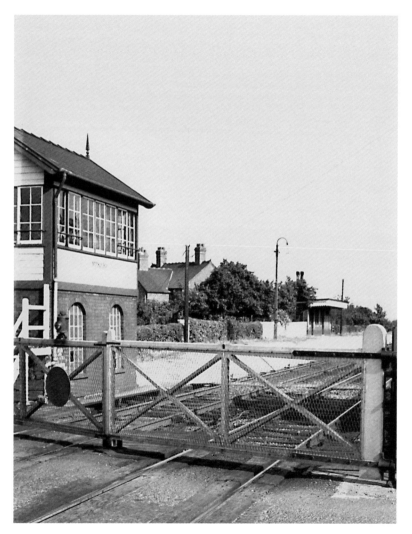

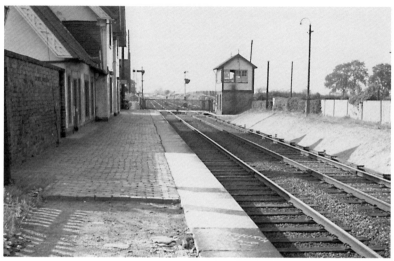

Baschurch

From Leaton, the line turns north-westwards as it undulates towards Gobowen, a series of short ascents being balanced by corresponding descents as the railway follows the contours of the surrounding farmland. A small halt and siding was provided at Oldwoods, and there was a much more important station at Baschurch (102 miles). Opened on 14 October 1848, Baschurch had the usual range of facilities for passenger and goods traffic, including coal wharves, loading docks, cattle pens and a 3-ton yard crane. The station was one of a number of 'Country Lorry Centres' that had been set up throughout the GWR system during the 1920s and 1930s, and this meant that it handled goods and parcels consignments for collection or delivery in the surrounding area. The stationmaster here during the early 1960s was Mr E. E. Evans, while other staff included porter H. G. Smith and permanent way man J. Walley; H. G. Smith later transferred to nearby Leaton. Baschurch was closed to passengers with effect from 12 September 1960.

Rednal & West Felton

Rednal & West Felton (107½ miles) was opened on 14 October 1848. The main station building was on the down side, and there was a subsidiary building on the up platform; both platforms were 280 feet in length. The goods yard, which was sited to the north of the platforms on the down side, incorporated a lengthy goods siding that was linked to the up and down line main lines by trailing connections. Two dead-end sidings diverged southwards from the principal goods line, and there was, in addition, a short spur or headshunt at the northern extremity of the goods line. The main siding could hold twenty-six short wheelbase wagons, while the two dead-end sidings could accommodate a further twenty-four vehicles. The yard was equipped with loading banks and a 3-ton fixed hand crane. The signal box was normally worked only when goods trains called in the yard, or when passenger trains had vehicles to attach or detach – at other times it was switched out.

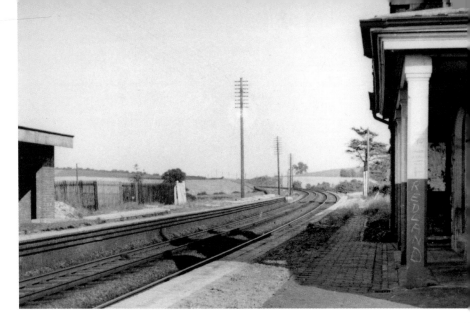

The line crossed the Montgomery Canal at the north end of the station, and there was at one time a short siding on the up side that provided a direct rail link to the adjacent canal wharves. The canal bridge was the scene of a major accident on 7 June 1865 when a packed excursion train headed by two 2-4-0 locomotives was derailed while traversing a section of unsupported track that was being worked on by a permanent way gang. The PW workers had placed a flag on top of a pole as a warning to approaching trains, but this crude warning signal had been ignored or misunderstood by the driver of the leading engine, resulting in his failure to reduce speed when approaching the point where the men were working. Eleven passengers and two of the enginemen were killed, and over thirty people were injured when the thirty-four-vehicle train careered off the rails in Rednal station.

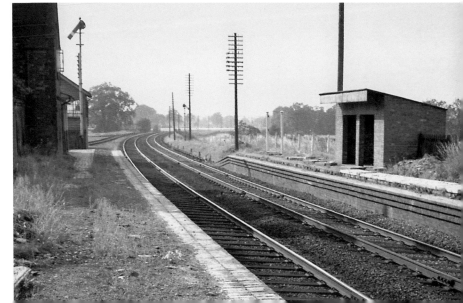

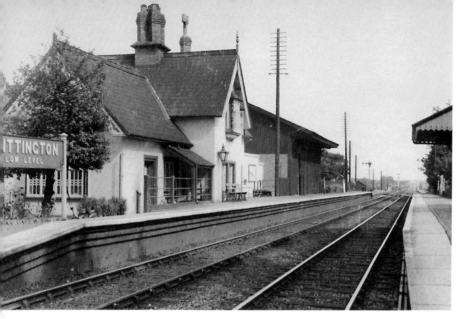

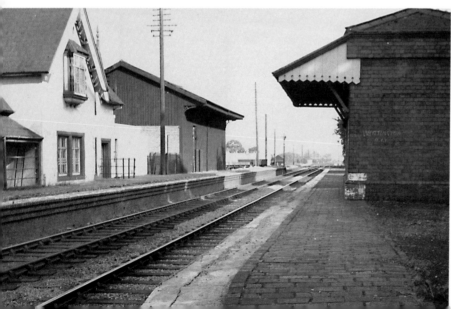

Whittington Low Level

Leaving the site of this long-forgotten Victorian tragedy, present-day trains climb a 1 in 132 gradient as they continue north-west towards the next station at Whittington (110½ miles). Whittington was a two-platform station with a small goods yard on the up side. The platforms were 335 feet in length, and the main station building was on the up side, while the A495 road crossed the line on the level at the north end of the station.

When opened on 14 October 1848, the station was known simply as 'Whittington', but after the 1922 Grouping it was designated Whittington Low Level to distinguish it from the nearby Cambrian Railways station, which became Whittington High Level. With both stations under Great Western ownership, the former Cambrian station was placed under the control of the GWR stationmaster, and goods traffic was concentrated at Whittington Low Level, the High Level yard being used for occasional consignments of cattle.

The track layout comprised a loop siding and three dead-end sidings, these facilities being on the up side. The loop siding was linked to the up main and down running lines by the customary trailing connections, while the three dead-end sidings were entered via connections that were trailing to the direction of up trains. The goods loop could hold up to thirty-seven wagons, while the goods sidings could accommodate a further eighteen vehicles. One of the sidings served a goods shed with a 50-foot loading platform, while the adjacent siding terminated in a 94-foot loading dock. The mileage siding at the rear of the yard could hold ten coal or mineral wagons.

A 1-ton fixed hand crane was provided in the goods shed, but the most interesting feature of the shed was undoubtedly a lifting platform or drawbridge that was fitted to the station side of the building for use when 'roadside' or 'smalls' traffic was unloaded in the passenger station and dealt with in the goods shed. Local regulations stipulated that no vehicles should be 'placed in or taken out of the warehouse' until the lifting platform had been raised and secured out of the way 'by means of the crossbar inside the warehouse'.

Gobowen

Maintaining its north-westerly heading, the North & West route passes beneath the now-closed Cambrian Railways main line as it climbs towards Gobowen on a rising gradient of 1 in 156. Having passed beneath a minor road bridge, trains enter Gobowen station (112½ miles), with the now-closed GWR branch from Oswestry converging from the left. Lengthy up and down platforms are provided here, the down side having a length of 505 feet, while the up platform is 540 feet long. There were originally bay platforms on each side, while the up and down platforms were formerly linked by a standard Great Western covered footbridge (now demolished). The busy A483 road crosses the line on the level at the north end of the platforms.

The main station building was located on the down side of the line, and there was a slightly smaller waiting room block on the up platform. The main building was an ornate, two-storey Italianate structure with a campanile-style tower at one corner and a semi-circular extension at the north end. Internally, the station provided the usual booking office, waiting room and toilet facilities for male and female travellers. Other accommodation in this extensive structure included stores, a parcels office and a ladies' waiting room. The Grade II listed building was refurbished in 1989 as part of a joint venture between the Rural Development Commission, the Railway Heritage Trust, Shropshire County Council, Oswestry Borough Council, English Estates and BR.

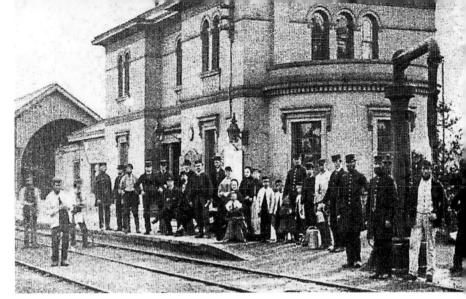

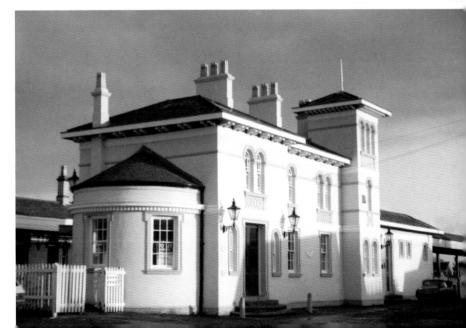

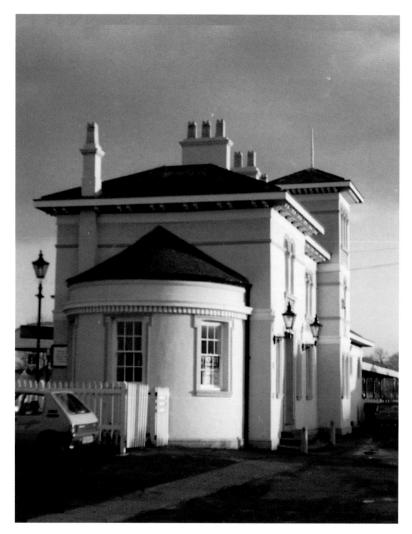

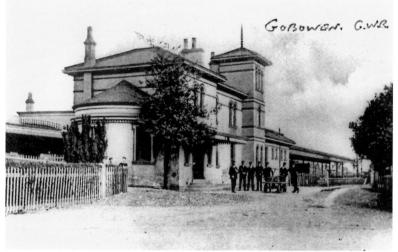

Gobowen – The Main Station Building

The station building at Gobowen is attributed to locally based architect Thomas Penson, who carried out much work on the Shrewsbury Oswestry & Chester Junction Railway, as well as designing many buildings in the contiguous counties of Shropshire, Denbyshire, Montgomery and Flintshire. However, the building had obviously been extended and modified at various times between the 1840s and the turn of the century. At the north end, for example, the conical roof of the semi-circular extension hid three blocked window apertures, while detailed examination of the southern end of the structure suggested that the gentlemen's toilets may also have been a later addition. There were projecting canopies at the front and the rear and these too were later additions that tended to obscure the original architectural detailing. The building is no longer in railway use, the ticket office and waiting room having been transferred to the up side.

Gobowen – The Up Side Buildings

The up side buildings are similar to those on the down side in that they have low-pitched, hipped roofs and round-headed Italianate windows, together with a projecting platform canopy. The main construction materials are brick and stone, and the roof is covered by grey slate. Although of matching architectural style, the up side building is more modern than its counterpart on the down platform, having been added by the GWR during the nineteenth century. Both platforms are covered by round-topped canopies that extend southwards for a considerable distance. The canopies are roofed in corrugated iron sheeting and supported by central pillars. The wooden valancing around the edges of the canopies sport the usual Great Western 'V-and-hole' decoration, two holes being provided in this case. The upper picture is looking southwards from the level crossing, while the lower view is looking northwards along the up platform as a steam railmotor car enters the station.

Although Gobowen station serves a relatively small village, its status as the junction for branch services to Oswestry gave it an added importance in operational terms, and for this reason the station needed a relatively large staffing establishment. In 1903, for instance, the station employed twenty-six people, while in 1923 the labour force had risen to twenty-eight. The stationmaster here during the early 1900s was Edward Foster, who was in office around 1913. Later stationmasters included Mr Lovekin, who was in charge of the station during the 1940s and George Windsor, who worked at Gobowen during the period 1945–56; another stationmaster during the BR period was Mr F. W. Caldwell, who moved to Gobowen in 1960 after previous service at Craven Arms, Cosford, and other local stations.

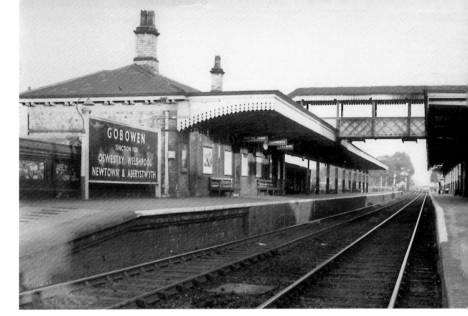

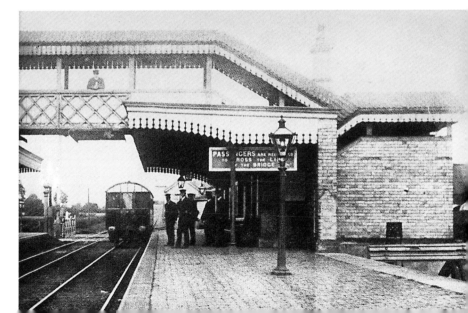

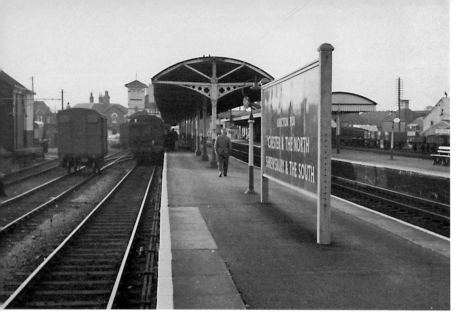

Gobowen – Goods Facilities

Gobowen's goods facilities were quite extensive, with an array of sidings provided on each side of the running lines. The usual coal wharves, cattle loading pens and end-loading docks were available, together with a 2-ton fixed hand crane. The down yard contained three sidings and a short spur, one of these sidings being an engine relief road for the branch bay, while another timber-framed siding served the goods shed. The up yard was more commodious than the down side yard, and its four dead-end sidings were able to accommodate up to 159 short-wheelbase goods vehicles; the up sidings were used primarily for marshalling purposes, whereas the down side yard was the goods yard proper. There were, in addition, three further sidings beside the Oswestry branch on the west side of the station.

The types of freight traffic handled at Gobowen during the British Railways period included coal and general merchandise, together with consignments of sugar beet from local farms, the latter being despatched in coal wagons after they had been cleaned out. Sundries and passenger-rated traffic was also quite heavy, and it was not uncommon for twelve trolley loads of mail and parcels to be transferred from the Oswestry branch train to main line workings. Up to eight horseboxes were often loaded at Gobowen on Thursdays for Wrexham horse fair, while milk traffic also built up in the post-war years, with milk tanks being sent from Forden (near Welshpool) to Gobowen and thence to Marylebone. In 1965, milk traffic was transferred from the United Dairies depot at Ellesmere to Gobowen, and for the next three years milk was brought by road to the station and then pumped into milk tank wagons in the goods yard.

The upper picture shows the goods yard during the 1960s, the goods shed being visible on the extreme left, while the colour picture, from a 35-mm slide, shows a former GWR road delivery lorry at Gobowen around 1963; the vehicle is in BR red-and-cream livery.

Gobowen – Goods Facilities

Gobowen's importance stemmed mainly from its role as the junction for Oswestry, and the station handled very little originating goods traffic; in 1903 only 3,587 tons of goods was dealt with, though this meagre figure had increased slightly to 5,260 tons by 1923. Passenger bookings, on the other hand, were somewhat healthier, with about 70,000 bookings a year during the pre-grouping period. In 1903 the station issued 66,257 tickets, while in 1923 over 70,000 tickets were issued. The development of rival forms of transport after the First World War resulted in a loss of traffic on rural lines, but Gobowen nevertheless remained comparatively busy during the during the later 1930s, with 49,848 bookings in 1938. In more recent years the station has generated around 200,000 passengers journeys per annum.

Gobowen's goods traffic was run down during the 1960s, but the goods yard received a new lease of life during the mid-1970s, when it was adapted for use as a local coal concentration depot. The accompanying pictures, taken in the 1990s, show hopper coal wagons in the surviving sidings – the infrastructure included a wire-haulage system whereby individual wagons were hauled along the sidings to the discharge point. Coal traffic finally ceased in 2007.

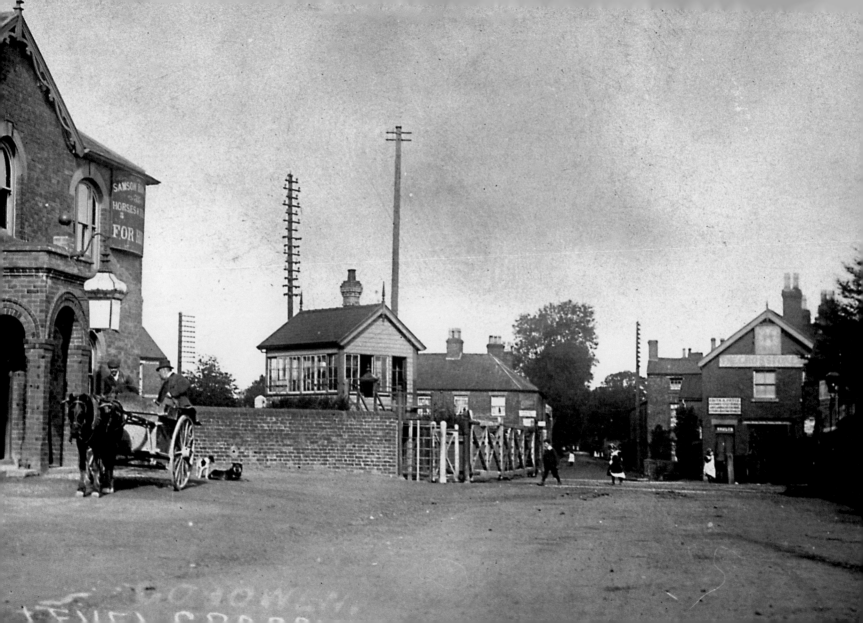

Gobowen – The Cross Foxes

Gobowen station is sited conveniently close to two public houses, the Cross Foxes being on the north side of the railway while the Hart & Trumpet Hotel is sited immediately to the west of the level crossing. This postcard view of around 1935 shows the northern side of the level crossing, with the Cross Foxes Inn to the left of the picture.

Gobowen

Class '50' locomotives Nos 50007 *Sir Edward Elgar* and sister locomotive No. D400 approach Gobowen with the 3.58 p.m. Chester to St Pancras 'Court Chester' railtour on 13 June 1992. The train had left Chester over half an hour later than scheduled, but it had already made up much of the time before reaching Gobowen.

Opposite: Gobowen

The Italianate architecture of the Hart & Trumpet echoes that of Penson's nearby station building, suggesting that the hotel may have been contemporaneous with the Shrewsbury & Chester Railway.

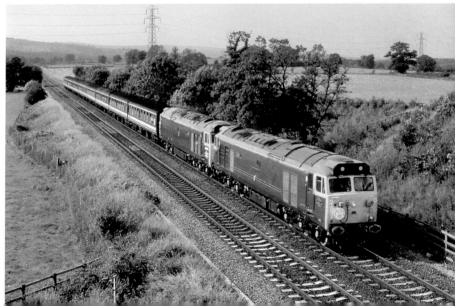

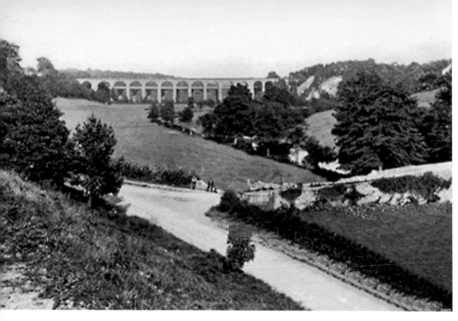

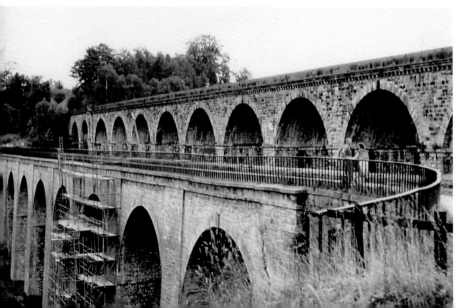

Weston Rhyn & Chirk Viaduct

Accelerating away from Gobowen, trains head northwards through the tree-dotted landscape of north Shropshire as they approach the invisible border between England and Wales. Weston Rhyn station (114¼ miles) was opened as 'Preesgwyn', but its name was changed to 'Preesgweene' before the name Weston Rhyn was finally adopted in 1935. A plan of this station (as Preesgweene) will be found on page 104. Weston Rhyn was closed to passengers in September 1960.

Passing the site of Trehowel Halt, which was opened in 1935 and closed in 1951, northbound workings cross the impressive Chirk Viaduct. Designed by Henry Robertson, the Shrewsbury & Chester engineer, the viaduct is 100 feet high and 269 yards in length. It carries the railway across the Ceiriog Valley and, as originally built, it consisted of ten semicircular arches, each with a span of 45 feet, together with laminated timber arches at each end each. The timber arches spanned 120 feet, but these were replaced by four additional masonry spans in 1858 and 1859, the rebuilt viaduct having a total of fourteen arched spans. The railway viaduct is built alongside an equally spectacular aqueduct that was designed by William Jessop (1746–1814) and Thomas Telford (1757–1834) to carry the Ellesmere Canal over the valley. Completed in 1801, the aqueduct is 200 yards long and 70 feet high, and has ten masonry arches. The black-and-white photograph provides a distant view of the viaduct around 1912, while the colour view, taken by the late John M. Strange, shows the viaduct and the adjacent aqueduct during the early 1970s.

Opposite: Chirk Viaduct

Class '31' No. 31434 and class '37' No. 37896 cross Chirk Viaduct with the 5.50 a.m. Pathfinder Tours Reading to Crewe 'Rex Ham' railtour on 28 February 1998. No. 31434 was a last-minute replacement for class '37' No. 37680, which had been commandeered to work a freight train.

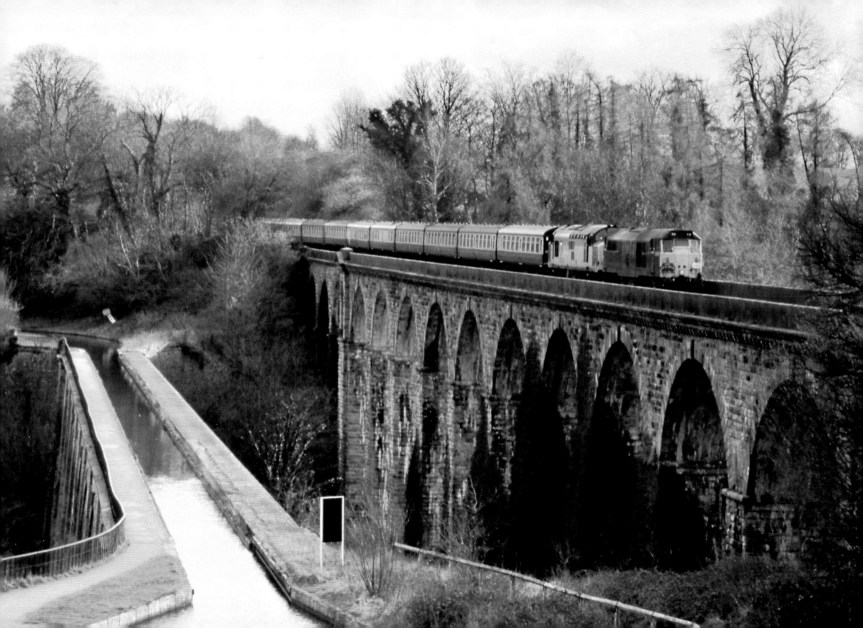

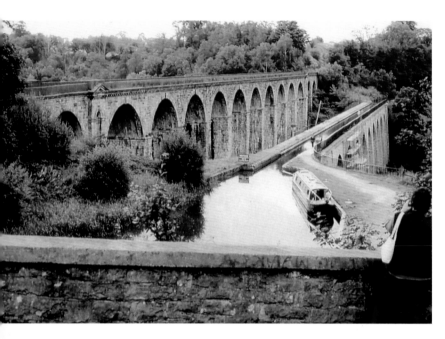

Right: Chirk

Having passed through Chirk Tunnel, trains emerge into a cutting that extends as far north as Chirk station (115½ miles). Opened by the S&CR on 14 October 1848, Chirk was once the junction for the long-defunct Glyn Valley Tramway, which had its own station alongside the main line. Prior to rationalisation, the GWR station had boasted two platforms, both 520 feet in length, together with a goods yard and a number of private sidings that served coal mines and other local industries. The main station building was on the up side, and there was a much smaller building on the northbound platform. As usual on the Shrewsbury & Chester line, the main station building was a substantial, stone-built structure in the Tudor-Gothic style, whereas the down side building was of standard Great Western design.

Left: Chirk Viaduct

A further view of Chirk Viaduct, looking north towards Chester, with the canal aqueduct in the foreground. The canal is carried across the valley in a trough with masonry side walls and a cast-iron base, the spandrels of the arches being hollow to allow for any leakage. The railway and waterway enter separate tunnels on the north side of the Ceiriog Valley, the railway tunnel being just 52 yards in length, whereas the canal tunnel is somewhat longer, with a length of 459 yards.

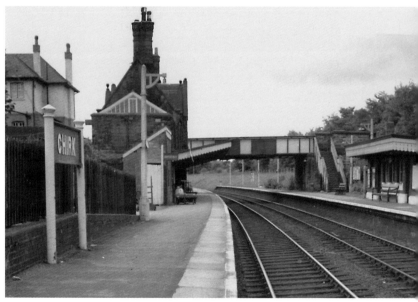

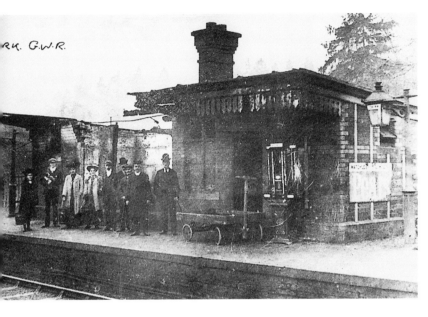

RK. G.W.R.

Left: Chirk

This Edwardian postcard view shows the aftermath of a destructive fire that engulfed the down side station building on Monday 11 December 1905. The fire was discovered at about 3 o'clock, and despite the efforts of the stationmaster, Mr Littlehales, and his three daughters, who tried to extinguish the conflagration with buckets of water, two waiting rooms and a lavatory were burned out, destroying the costumes and stage props of a group of entertainers called the 'Merry Mimics', who had stored their theatrical equipment within the building after performing in Chirk on Saturday night. The damaged structure was rebuilt by the GWR in a similar architectural style, the replacement building being more or less the same as its ill-fated predecessor. At the time of the fire, Chirk was used by about 50,000 passengers per annum. In 1903, for example, the station booked 50,204 tickets, rising to 53,252 in 1913, while goods traffic amounted to around 325,000 tons per annum during the early 1900s.

Right: Chirk

A general view of the station, looking north towards Chester during the early 1960s. The rebuilt down side station building can be seen to the left, while the original Shrewsbury & Chester building can be glimpsed to the right of the picture; the projecting canopy was added by the GWR. Regrettably, the Grade II listed station building was demolished in 1987, and the platforms at this now-unstaffed station are now equipped with simple waiting shelters, which are, nevertheless, of traditional appearance.

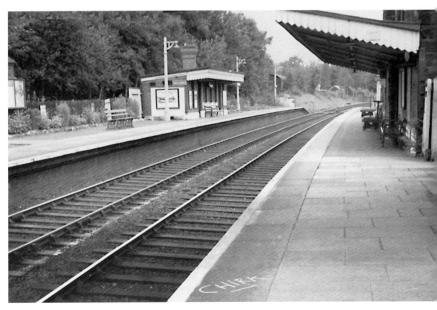

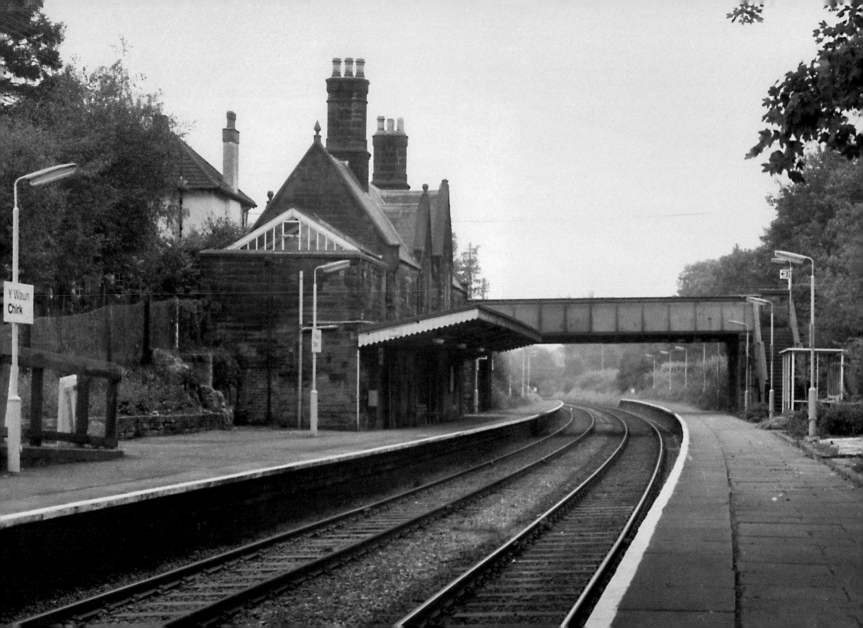

Chirk – The Glyn Valley Tramway

The upper view shows the exchange sidings on the down side of the running line, with narrow gauge Glyn Valley Tramway wagons drawn up alongside standard gauge vehicles, so that slate, granite and other consignments can be transferred. The Ellesmere & Glyn Railway was authorised in 1870 and opened in 1873 as a horse-worked tramway serving the local quarries. Steam locomotives were introduced in 1888, by which time the name of the undertaking had been changed to 'the Glyn Valley Tramway'. Passenger services were inaugurated in March 1891 on a 6½ mile section of line between Chirk and Glynceiriog, much of the line being laid alongside public roads. The GVT was laid on an unusual gauge of 2 feet 4½ inches and, as a roadside tramway, it was subject to a strict speed limit of 8 mph.

The lower photograph is a posed view showing a GVT passenger train, probably during the 1890s. The locomotive is *Sir Theodore*, one of two 0-4-2T tank locomotives supplied by Beyer Peacock & Co. of Manchester, the other engine being named *Dennis*. In compliance with Board of Trade regulations concerning tramway locomotives, the two engines were equipped with condensing apparatus, while their wheels and motion were fully enclosed; the engines were designed to run bunker-first, as shown in the photograph. A third engine of the same type, named *Glyn*, was obtained in 1892, and in 1921 the GVT purchased a Baldwin 4-6-0T from the War Department. The engines were originally painted green with red-and-white lining, while passenger vehicles sported an attractive green and cream livery.

The rapid development of road transport after the First World War caused a severe loss of traffic on the Glyn Valley route, resulting in the cessation of passenger services in April 1933 and closure of the line in its entirety on Saturday 6 July 1935.

Opposite: Chirk

This *c.* 1970s view, which is looking south towards Shrewsbury, shows the plate girder footbridge that links the two platforms and abuts the road overbridge.

The Glyn Valley Tramway

Left: A typical GVT train at Pontfaen, to the west of Chirk. The engine is, as usual, running bunker first, while the four-wheeled passenger vehicles are marshalled at the front of the train, with slate wagons at the rear. The GVT owned fourteen coaches and two brake vans, together with about 230 goods vehicles.

Below left: A detailed view of the Baldwin 4-6-0T locomotive.

Below right: Redundant GVT passenger vehicles languish on a siding at Chirk after the withdrawal of passenger services. Two Glyn Valley Tramway coaches were later restored for use on the Talyllyn Railway.

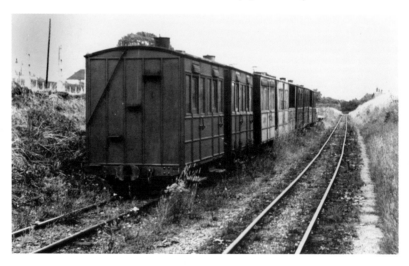

Cefn

On departure from Chirk, trains head northwards, passing the rail-served Kronospan factory, which produces wood-based panels for use in furniture, flooring and building construction. Beyond, the line passes through the 56-yard Whitehurst Tunnel. Whitehurst Halt, at the north end of the tunnel, was opened on 1 October, near the site of a much earlier stopping place that had been known as 'Llangollen Road'; the halt was closed with effect from 12 September 1960.

Continuing northwards, trains cross the broad valley of the River Dee on Cefn Viaduct, which, like Chirk Viaduct, was designed by Henry Robertson. The viaduct is 510 yards long and has nineteen semicircular arches, each with a span of 60 feet. At its highest point, the viaduct rises 146 feet above the river, while at the time of its construction this massive stone structure was said to have been the longest railway viaduct in the world. Cefn station (118 miles), on the north side of the viaduct, was opened in 1849 and closed with effect from 12 September 1960.

Rhosymedre Halt

There were a number of halts on this section of the Shrewsbury & Chester line, many of these having been built for the benefit of local coal mining communities. Rhosymedre, between Cefn and Ruabon, was a typical example. This unstaffed stopping place was opened on 1 September 1906 and closed with effect from 2 March 1959, while its modest facilities consisted of timber-built platforms and a pair of characteristic GWR 'tin pagoda' sheds.

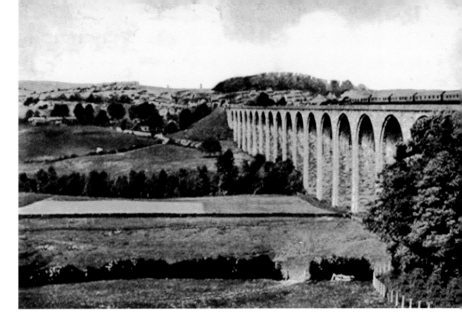

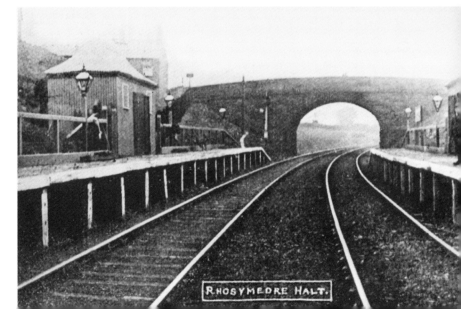

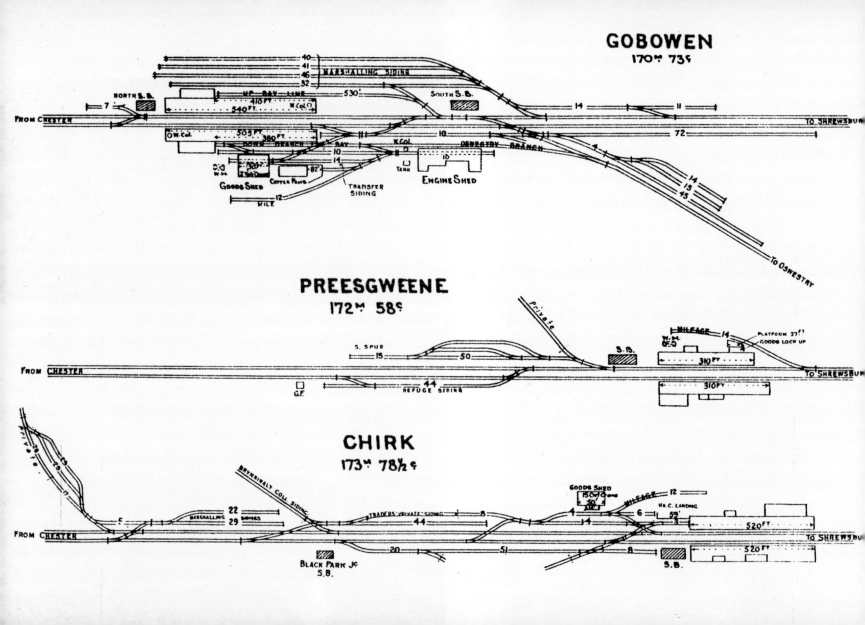

Ruabon

Ruabon, some 25½ miles from Shrewsbury and 119¾ miles from Newport, was the junction for a range of destinations throughout North Wales that could be reached via the now-closed cross-country line to Barmouth, which converged with the main line at Llangollen Junction on the southern approaches to the station. The Barmouth route was opened in stages by a number of different companies, the first section to open being the Vale of Llangollen Railway, which was opened on 2 June 1862, while the final link between Dolgellau and Penmaenpool was provided by the Cambrian Railways on 21 June 1869.

Up and down platforms were available for main line traffic, and there was a bay platform for Barmouth services on the down side. The platforms were linked by a fully roofed lattice girder footbridge, while Church Street was carried across the line on a stone-arched bridge at the north end of the platforms. The upper photograph is looking northwards along the down platform on 26 June 1958, while the lower view is looking southwards along the up platform. The Tudor-Gothic station building on the up side is an 'H'-plan structure, with a central hall block flanked by two gabled cross wings.

Opposite: Some Station Plans

Taken from an official GWR publication of around 1922, these diagrammatic plans show the track layouts at Gobowen, Preesgweene and Chirk stations. The layout at Chirk includes various private sidings which, at that time, included links to Black Park Colliery and Chirk Castle Lime Works.

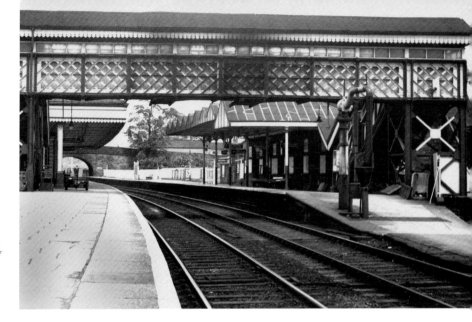

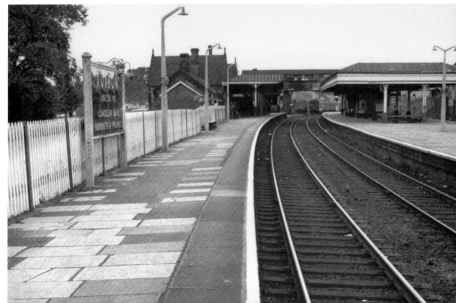

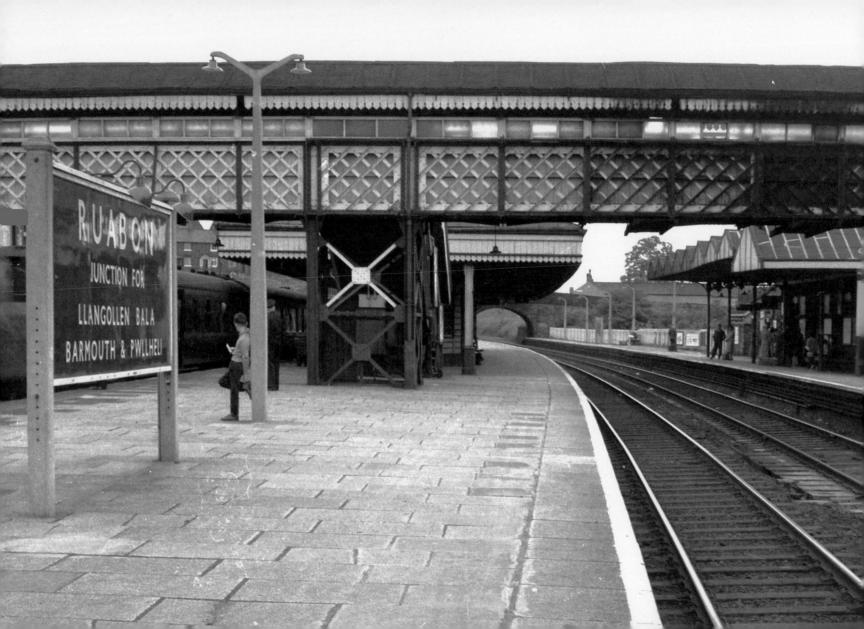

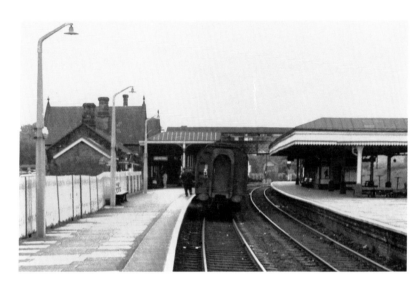

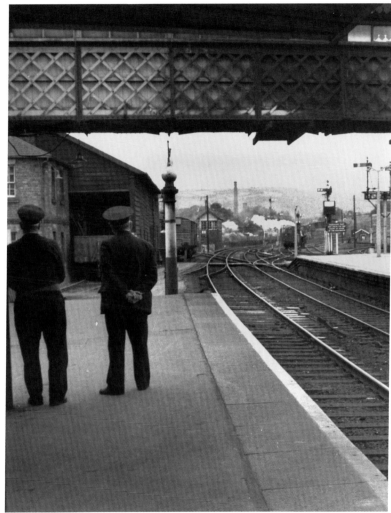

Ruabon

Above: A southwards view along the up platform during the early 1960s; the main station building can be seen to the left.

Right: A glimpse of the goods yard, photographed from the south end of the up platform around 1960. The goods shed can be seen to the left, while Ruabon Middle Signal Box can be discerned in the distance; the box had 59 levers and it remained in use until September 1965. In 1903, Ruabon booked 85,964 tickets, while in 1923, 96,998 ordinary tickets and 234 seasons were issued. In recent years, passenger bookings have amounted to around 75,000 journeys per annum.

Opposite: Ruabon

A general view of the station around 1961, looking north towards Chester with the up and down platforms to the right and the Barmouth bay platform visible to the left.

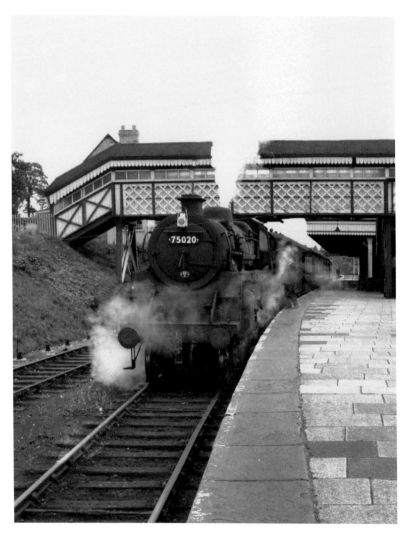

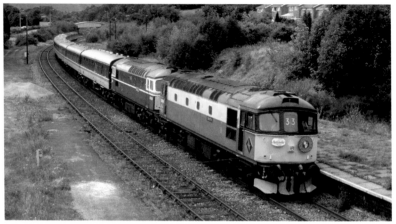

Ruabon – Steam & Diesel Power

Above: Class '50' locomotives Nos 50026 *Seafire* and 33008 *Eastleigh* hurry through Ruabon station with the 8.05 a.m. Pathfinder Tours Bristol Temple Meads to Carlisle 'Crompton Crusader' railtour on 30 July 1995. A new housing estate has sprung up on former railway land to the left of the picture since this photograph was taken.

Left: The final view of Ruabon depicts British Railways standard class '4MT' 4-6-0 No. 75020 at the head of a Barmouth service.

The Ruabon to Barmouth line was listed for closure in the Beeching Report, but closure was postponed because of delays in arranging a replacement bus service. In the event, severe flooding in December 1964 decided the issue by damaging the line to such an extent that services were suspended. A bus service began on 14 December 1964, and railway passenger services were resumed between Ruabon and Llangollen and between Bala and Dolgellau on 17 December. In the interim, it had been decided that final closure would take effect from 18 January 1965, when a new through bus service was introduced between Wrexham and Barmouth. Happily, parts of the former Ruabon to Barmouth route have been revived as heritage railways; the Llangollen Railway has been opened between Llangollen and Carrog, while the narrow gauge Bala Lake Railway has been established between Bala and Llanuwchllyn.

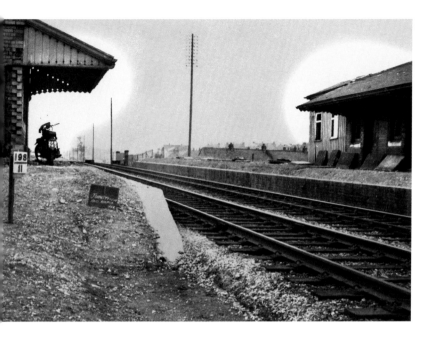

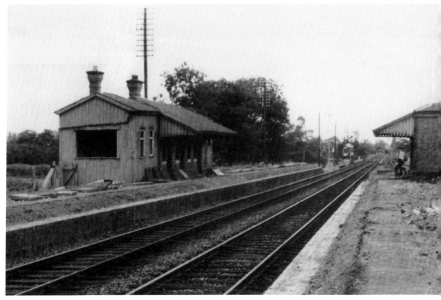

Left: **Johnstown & Hafod**

Johnstown & Hafod (121¼ miles) was less than 2 miles further on. This wayside stopping place was a comparatively late addition to the local railway network, having been opened by the GWR on Monday 1 June 1896. The *Wrexham Advertiser* reported that the new station had been built 'at a point where a station originally stood', the implication being that Johnstown & Hafod may have been on or near the site of an earlier stopping place known as 'Rhos', which appears on the early timetable reproduced on page 10. There was no goods yard as such, although the station handled large quantities of private siding traffic.

Right: **Johnstown & Hafod**

The 1938 RCH *Handbook of Stations* shows two industrial concerns at Johnstown & Hafod, one of these being Hafod Colliery, operated by the Ruabon Coal & Coke Co., while the other was the Dennis (Ruabon) Ltd Brickworks, the latter facility being sited to the east of the railway and served by a standard gauge siding from the Hafod Colliery system, as well a 1 foot 9½ inch gauge tramway. The station was closed with effect from 12 September 1960, but the colliery sidings remained in use until 1968. This post-closure view is looking north towards Chester during the 1960s, the colliery sidings being discernible in the distance.

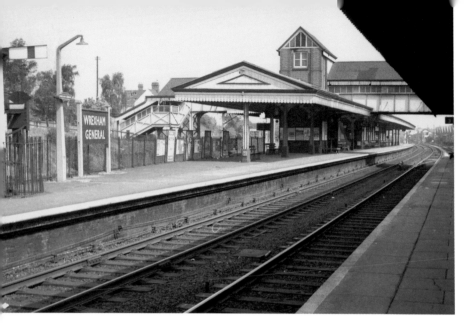

Wrexham General

Situated 30½ miles from Shrewsbury and 125 miles from Newport, Wrexham General station is the most important intermediate stopping place on the Shrewsbury & Chester route. It has two staggered platforms for up and down traffic, the down platform being further to the north than its counterpart on the up side. The down platform, shown in the upper view, is an island with tracks on either side, although the southernmost extremity of the platform face has been fenced off, which means that passengers can only use the northern end. In pre-Grouping days, a Great Central Railway station known as 'Wrexham Exchange' was sited immediately to the west, but this facility is now part of the GWR station. Two additional bays are available on the up side, but these are not at present used for passenger traffic.

The platforms are now numbered from 1 to 4, Platforms 1 and 2 being the main up and down platforms, while Platform 3 is the outer face of the above-mentioned island platform, and Platform 4 is the former Great Central station, which was opened by the Wrexham, Mold & Connah's Quay Railway on 1 May 1866. The up and down platforms are linked by a covered footbridge with two prominent lift towers, while Regent Street is carried across the running lines on a skew girder bridge towards the south end of the station. The bridge is wide enough to span Platform 1, which extends southwards for a considerable distance beyond the bridge aperture, as shown in the lower photograph.

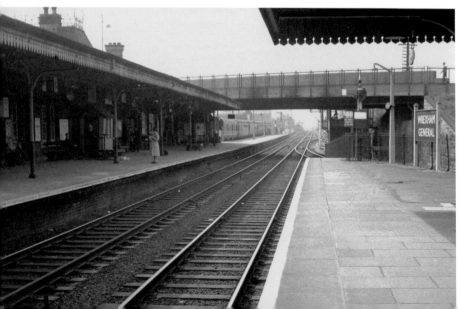

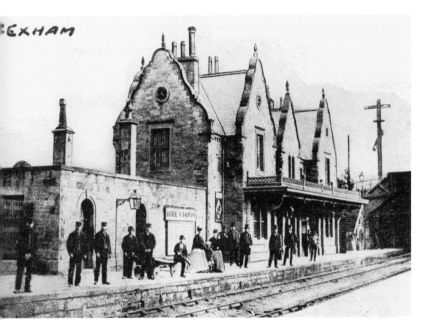

Left: Wrexham General – The Original Station Building

When opened on 4 November 1846, Wrexham had been equipped with an ornate, Jacobean-style station building on the up side; the building was two storeys high, with a central hall and two projecting cross wings, while its steeply pitched roof was enlivened by an array of ornate chimney stacks. This distinctive structure had been designed by Thomas Penson, the locally based architect who had been responsible for several other stations on the S&CR route, including those at Shrewsbury and Gobowen.

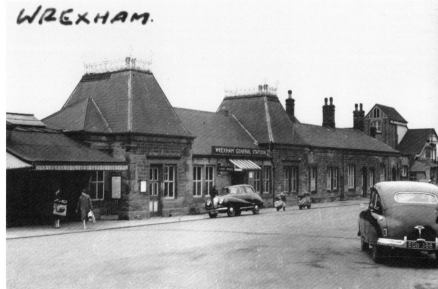

Right: Wrexham General – The New Station Building

By the end of the Victorian period, Wrexham station had became inadequate in relation to increasing traffic requirements and, in the early years of the twentieth century, the GWR carried out a major rebuilding scheme. The old station building was replaced by much longer range of single-storey buildings in the then-standard Great Western architectural style. Perhaps significantly, the new building, which is still extant, is of hybrid brick-and-stone construction, suggesting that a substantial part of the 1846 building may have been incorporated into the new structure. The likeliest explanation of this is that the stone-built portion of the present-day building, with its distinctive doorways and window apertures, is the lower part of Penson's original station building.

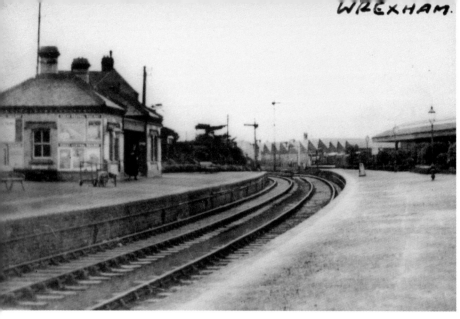

WREXHAM.

Wrexham – The Great Central Station

The former Great Central station was only a few yards to the west of the Great Western line, the GCR and GWR stations being laid out on slightly diverging alignments. Two platforms were provided, and the station building was on the down side. The building was of white brick construction, and it followed the familiar and serviceable 'H'-plan, with a central block and two hip-roofed cross wings. There were no goods facilities, Wrexham Exchange being a passenger-only stopping place. A footbridge provided a physical link between the GWR station and the up GCR platform, while the station was signalled from a typical Great Central gable roofed signal box. This cabin, which was sited immediately to the north of the platforms on the down side, also controlled a junction between the GWR and GCR lines; the cooperation of both signalmen was required in order to pass a train between the two systems.

Wrexham – The Great Central Station

Ex-Great Central 'N5' class 0-6-2T No. 9289 enters what was then Wrexham Exchange on 9 May 1949. The GCR ticket office was closed in April 1969, when conductor-guard working was introduced on the Wrexham to New Brighton route, while the platform that can be seen on the right of the picture was taken out of use in 1973. Eight years later, in 1981, the former GWR and Wrexham, Mold & Connah's Quay stations were combined, and the surviving GCR became Platform 4 of Wrexham General station.

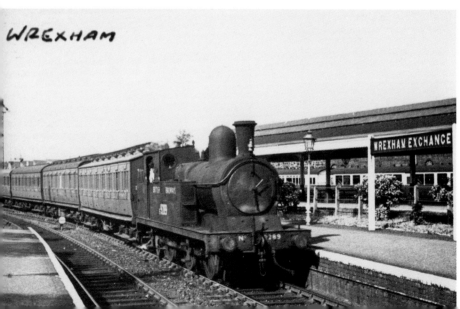

WREXHAM

Wrexham General

A general view of the former Great Central station, photographed from Platform 3 during the early 1960s. Prior to rationalisation, Wrexham General had boasted ample goods-handling facilities. The goods shed was a large, brick-built structure, sited to the north of the passenger station on the up side, while other goods sidings were situated to the south of the passenger station, on both sides of the running lines; the cattle loading pens were sited to the south of the down platform. Further sidings were available at nearby Croes Newydd, while Croes Newydd was also the site of a motive power depot, which was coded '89J' (becoming '89B' in 1961 and '6C' in 1963). In 1921, Croes Newydd shed had an allocation of twenty-nine locomotives and three steam railmotors, while in 1947 the allocation had increased to thirty-nine locomotives.

Wrexham General – Tickets & Traffic Statistics

A selection of tickets from the Shrewsbury to Chester section of the North & West route, including (*bottom right*) a combined rail and river excursion ticket from Chester to Oxford. In 1913, Wrexham booked 654,365 tickets, but the number of ordinary ticket sales declined after the First World War. This decrease was attributable to the increasing use of season tickets. In 1931, for example, there were 167,462 ordinary bookings and 942 seasons. By the 1930s, passenger bookings had fallen to around 170,000 ordinary tickets per annum, although over 1,000 season tickets were issued each year. In 1937, the station issued 165,199 ordinary tickets and 1,050 seasons, while in 1938 ticket sales amounted to 153,824 ordinary single and returns and 1,056 season tickets.

Wrexham General generated 320,996 tons of freight traffic in 1903, rising to 350,384 tons in 1913. There was, thereafter, a steady increase in the volume of goods traffic, around 800,000 tons being dealt with each year during the mid-1930s, while in 1936 over 1,000,000 tons of freight was handled; traffic from the Cambrian goods yards at Wrexham Central and Caia was included with Wrexham General after 1925. Wrexham General, which is used by over 500,000 travellers per annum, is now one of the busiest stations in North Wales; in 2008/09 it generated 0.665 million passenger journeys, while in 2011/12, passenger usage amounted to 0.622 million journeys.

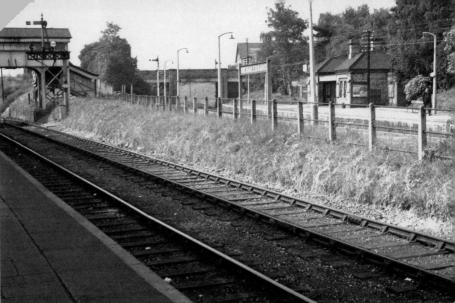

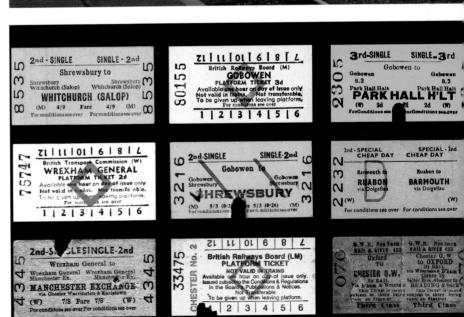

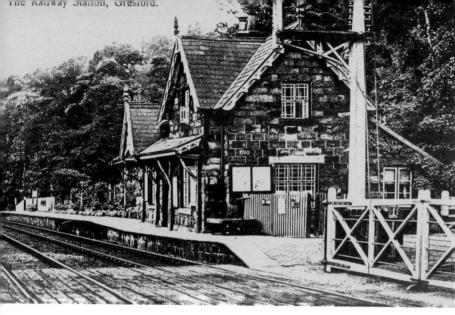

The Railway Station, Gresford.

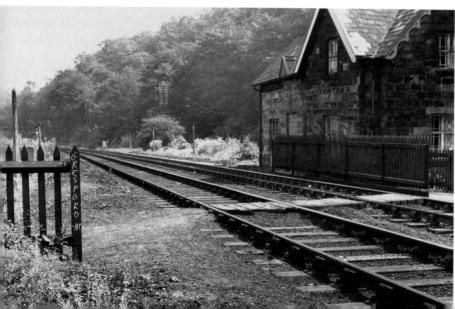

Gresford (for Llay)

On leaving Wrexham, down trains reach the start of Gresford Bank, a 4-mile descent on a falling gradient of 1 in 82, which takes the railway from the Denbighshire coalfield to the level pastures of Cheshire. The line twists and turns as it follows a wooded defile towards Gresford (128¼ miles), a small station that was opened on 4 November 1846. The 1938 Railway Clearing House *Handbook of Stations* lists Gresford as a passenger-only station, and although a refuge siding was provided on the up side, there was no provision for loading or unloading goods traffic. The main station building, designed by Penson, was on the up side, and a minor road crossed the line on the level at the south end of the platforms. This Edwardian postcard is looking north-west towards Chester.

Gresford (for Llay)

A post-closure photograph, taken after removal of the platforms. The rail-served Gresford Colliery, to the south of the station, was in use from 1911 until 1973, and traces of the mining industry can still be seen along this part of the S&HR route. The colliery, then owned by the Westminster & United Collieries Group, was the scene of an underground explosion on Saturday 22 September 1934. Over 260 men were trapped by the ensuing fires and, all attempts to extinguish the fire having failed, the Dennis Section of the colliery was sealed up, leaving the victims entombed deep below ground. The final death toll was 266, including three rescue men and one surface worker.

Opposite: Another postcard view of Gresford station during the early years of the twentieth century. The signal box features prominently to the right of the picture; this brick and timber cabin contained a 13-lever frame. Gresford station was closed with effect from 10 September 1962.

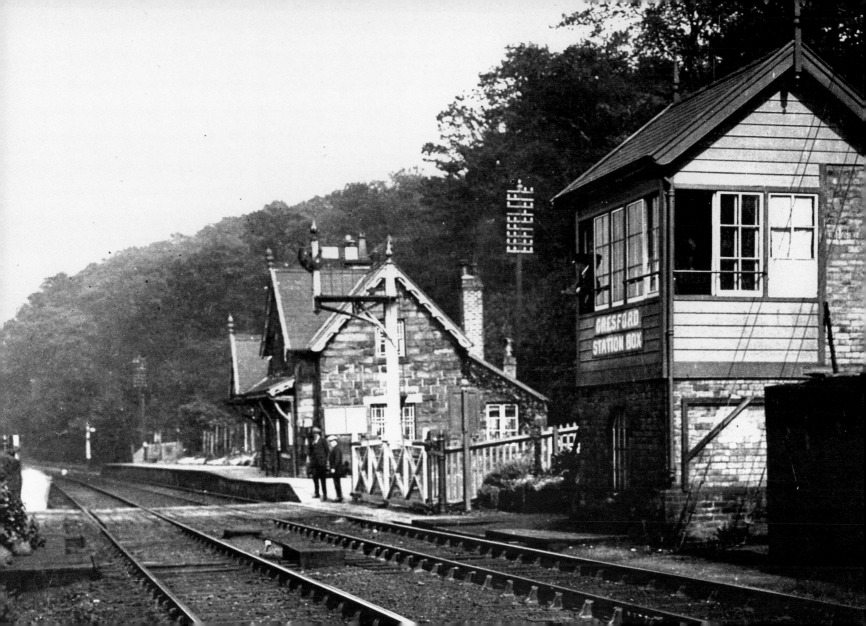

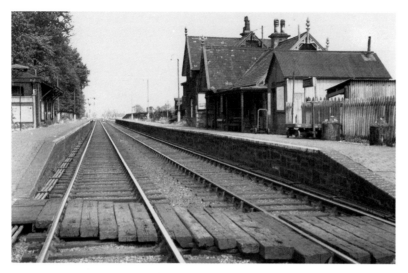

Rossett

Left: Still descending the formidable Gresford Bank, northbound services reach the abandoned station at Rossett (129½ miles), where the falling gradient eases to 1 in 264. Rossett was not one of the original stations, having been opened on 4 November 1866. The photograph is looking north towards Chester, probably during the early 1950s.

Below left: A view of the down platform, again looking north. The gable-roofed signal cabin dated from 1884; it was replaced by a new box in 1960, and this lasted until the singling of the line in 1986.

Below right: A southwards view from the up platform after demolition of the 1884 the signal box. Rossett was closed with effect from 26 October 1964, although trains continued to call for the benefit of pupils from the nearby Moreton Hall Girls' School.

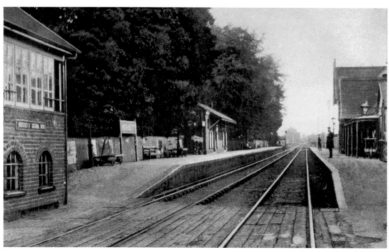

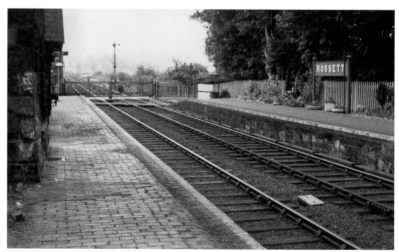

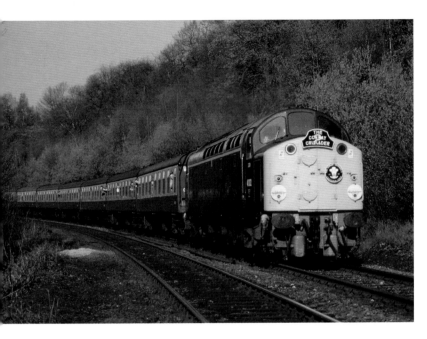

Right: Rossett – Singling of the Line

In 1994, a 10-mile section of line between Wrexham, Rossett and Saltney Junction was reduced to single track, this controversial downgrading operation being timed to coincide with a major road improvement programme. The Welsh Office agreed to contribute £300,000 towards the £700,000 cost of the scheme, which involved the introduction of colour light signalling and the modernisation of five level crossings, three of which were fitted with automatic lifting half-barriers. Press announcements pointed out that the singling would 'greatly reduce the cost to the Welsh Office of rebuilding two railway bridges affected by the road scheme'. The picture shows class '50' locomotives Nos 50049 *Defiance* and 50031 *Hood* near Rossett on the singled line with the 4.47 p.m. Chester to Reading Pathfinder Tours railtour on 16 August 2003. This tour had worked through to Chester earlier in the day as the 7.15 a.m. from Reading.

Left: Rossett – Descending Gresford Bank

Class '40' locomotive No. D200 descends Gresford Bank with the 6.45 a.m. Coventry to Holyhead 'Conway Crusader 2' railtour on 21 April 1984. This locomotive was numbered 40122 under the BR 'TOPS' scheme.

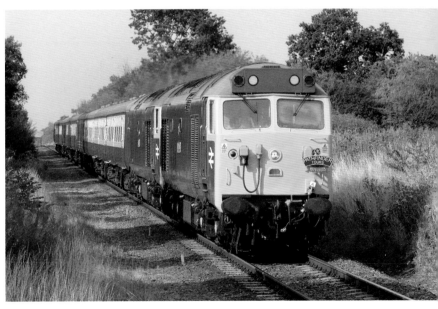

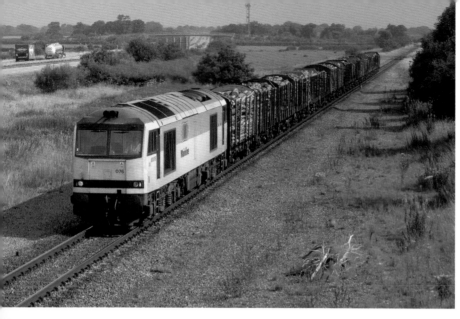

Rossett

Class '60' locomotive No. 60076 near Rossett on the single-line section with the 9.15 a.m. Warrington Arpley to Chirk timber train on 10 July 1999. At that time, class '37's or '56's were the more usual forms of motive power for this working. It is hardly surprising if the single line appears to occupy an exceptionally wide track formation, as not only was this formally a double track main line, but there were goods loops here as well. The road that can be seen in the background is the A483 from Wrexham to Chester, which is, in effect, a much needed bypass for the village of Gresford.

Chester – Crossing the Dee Bridge

Having crossed the Welsh border beyond Rossett, trains head north-north-eastwards towards their destination, passing the sites of closed stations at Pulford and Balderton en route. Pulford lost its passenger services as early as 1855, whereas Balderton (133¼ miles) was closed in March 1952. The S&HR line converges with the Chester & Holyhead route at Saltney Junction, and North & West services run eastwards along the Holyhead main line for a distance of 1¾ miles before finally coming to rest amid the noise and bustle of Chester station (137 miles). A peculiarity of this northernmost section of the route is that, having started their journeys as 'up' trains at Newport and become 'down' services on the Shrewsbury & Hereford line, North & West services enter Chester as 'up' workings on the Chester & Holyhead route! The picture shows class '40' locomotive No. 40001 crossing the Dee Bridge on the approaches to Chester.

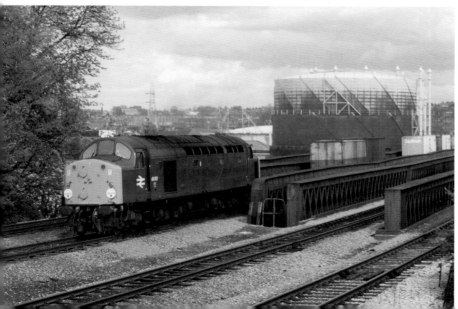

Chester General

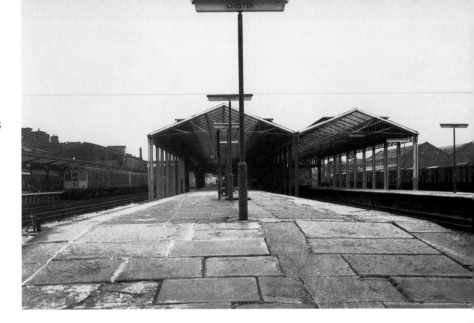

Railway development in the Chester area began as far back as the 1830s; the Chester & Birkenhead Railway was sanctioned by Parliament on 12 July 1837, while the Chester & Crewe Railway obtained its Act of Incorporation on 30 June 1837. These two lines were opened on 23 September 1840 and 1 October 1840 respectively, the Birkenhead line having a station at Grange Lane, while Chester & Crewe services terminated in an entirely separate station. When opened on 4 November 1846, Shrewsbury & Chester Railway had shared the Birkenhead Railway station, but in the event, these arrangements were merely temporary, and on 1 August 1848 a new 'General Station' was brought into use to serve the Chester & Holyhead, Shrewsbury & Chester, London & North Western and Birkenhead, Lancashire & Cheshire Junction railways. As we have seen, the Shrewsbury & Chester line subsequently passed into Great Western hands, and Chester General thereby became a joint GWR and L&NWR station.

Chester General is, by any definition, a large and complex station. The main station building, designed by the architect Francis Thompson (1808–95), is a two-storey Italianate-style structure with two 40-foot towers. There are, at present, seven platforms, Nos 3, 4 and 7 being the main through platforms, while Platforms 1 and 2 are east- and west-facing terminal bays on the 'down' side. Platforms 5 and 6 are east-facing bays on the 'up' side; the three through platforms are now signalled for bi-directional working. Platform 3 can accommodate eighteen coaches, while Platform 4 can hold up to fifteen bogie vehicles. The upper picture is looking westwards along Platform 4 during the 1960s; terminal Platforms 5 and 6 can be seen to the right, while a multiple unit formation occupies Platform 3, on the extreme left-hand side of the picture. The lower view is looking east towards Platform 4, which is an island with tracks on either side, the northernmost face being divided into two sections known as Platforms 7a and 7b; Platform 7b is now used solely by Merseyrail Electric services.

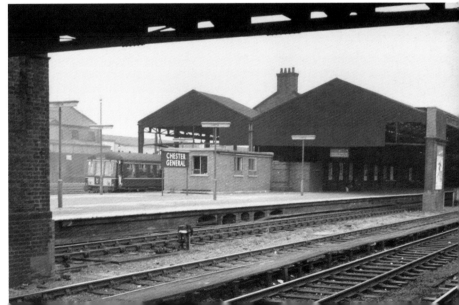

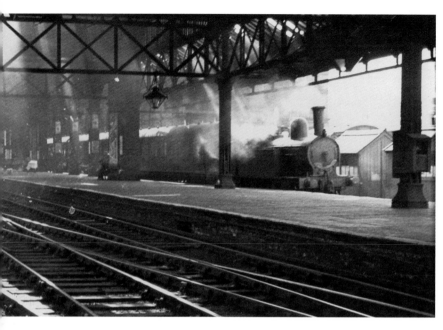

Right: Chester General

This photograph, dating from around 1970, shows the western end of Platform 4. The overbridge that can be seen in the distance carries Brook Street across the station. The Great Western motive power depot was sited immediately beyond the bridge – the site of the steam shed is now occupied by sidings and maintenance sheds for present-day multiple unit stock.

Left: Chester General

The platforms at Chester General were formerly covered by an overall roof, which was, in effect, a series of conjoined train sheds. The roof structures have now been partially dismantled, although the earlier roof coverings have, to some extent, been replaced by modern canopies, and substantial train sheds still remain above the central parts of the station. In steam days, the interior of the station was a somewhat gloomy place, as exemplified by this *c.* 1930s view of a former London & North Western Railway tank locomotive, shrouded in steam beneath the smoke-blackened roof girders.

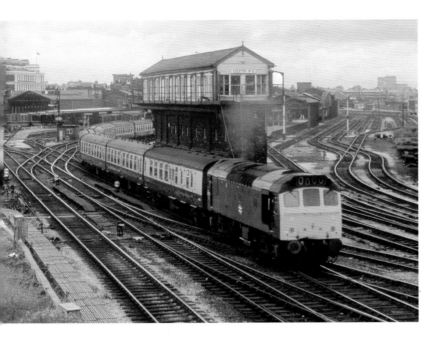

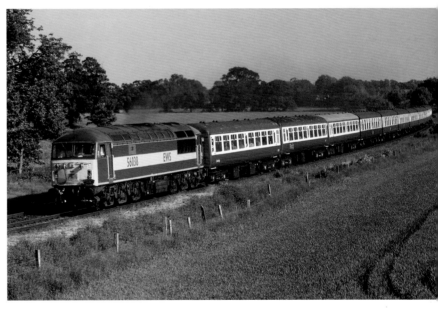

Left: **Chester No. 2 Signal Box**

Class '25' locomotive No. 25133 passes Chester No. 2 Signal Box as it pulls way from Chester at the head of the 1.05 p.m. service from Llandudno to Nottingham on 23 July 1977. Chester No. 2 Box was a standard London & North Western gable roofed cabin with a 182-lever frame; it was closed in connection with the Chester resignalling scheme in May 1984.

Right: **Hadnall**

Although Chester is often regarded as the northern extremity of the North & West route, many present-day trains continue their northwards journey over a purely London & North Western line between Shrewsbury and Crewe. This 32-mile line was authorised by Parliament on 20 August 1853 and built by Messrs Brassey & Field. The line was opened with little ceremony on Wednesday 1 September 1858, with an initial train service of five trains each way. The *Cheshire Observer* remarked that, 'there was no demonstration beyond that naturally to be expected from the arrival of the first passenger train in a country district'. The photograph shows class '56' locomotive No. 56038 passing the now-closed station at Hadnall (99 miles) with the Pathfinder Tours 'Crewe Invader' railtour on 1 June 2003. The abandoned station, which is hidden behind bushes in the background, was deleted from the railway system with effect from 2 May 1960.

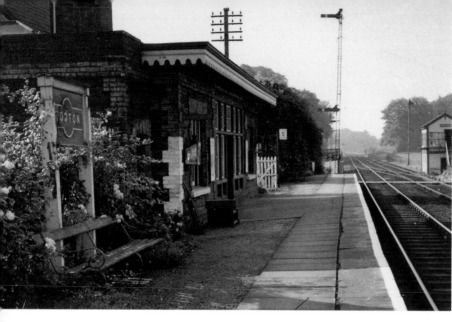

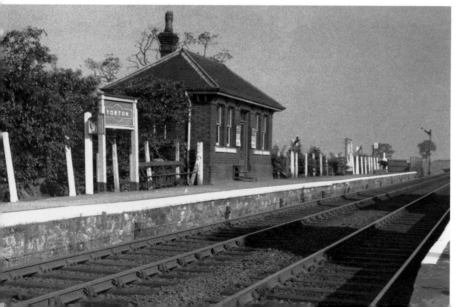

Yorton

The Shrewsbury to Crewe line is something of an anticlimax after the scenic splendours of the Welsh borders. The line heads more or less due north across the flat Midlands plain towards Whitchurch, and then turns north-eastwards to join the West Coast Main Line at Crewe. The upper view shows the main station building at Yorton (101¾ miles) which, since the demise of Hadnall, has been the first stop en route to Crewe. This small station had typical London & North Western Railway station buildings and a small goods yard that was able to deal with coal class traffic, livestock, horseboxes and general merchandise. The station is now an unstaffed halt with minimal facilities for the travelling public. The lower picture shows the subsidiary building on the northbound platform.

Wem

Right: Heading due northwards along dead-level alignments, down services soon reach Yorton (105¼ miles), which was opened, along with the other stations on this stretch of line, on 1 September 1853. The photograph, dating from around 1962, shows the up and down platforms 'framed' by the footbridge, the main station building being visible to the right.

Below left: Class '158' unit No. 158825 leaves Wem station with the 8.41 a.m. Crewe to Shrewsbury service on 4 June 2005. Although the signal box survives by virtue of the adjacent level crossing, the station itself now has only very basic passenger facilities.

Below right: A general view of the station during the early 1960s.

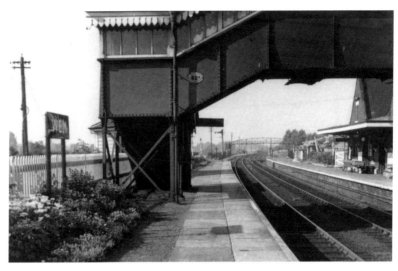

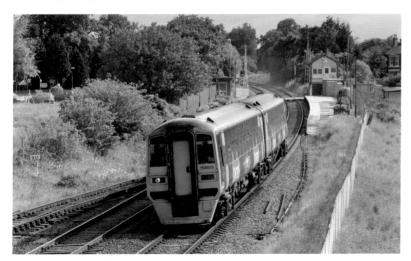

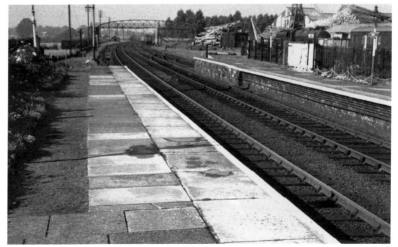

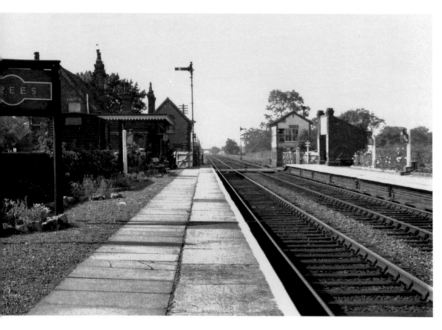

Right: **Prees**

A northwards view along the up platform, again taken during the 1960s. The goods yard sidings, seen to the right of the picture, were linked to the up and down running lines by trailing connections, so that the yard could be shunted by northbound or southbound trains.

Left: **Prees**

From Wem, the route continues through pleasant but unspectacular countryside to Prees (108½ miles). The track layout here incorporated up and down platforms and a small goods sidings, the yard sidings being on the up side, while a minor road crossed the line on the level at the south end of the platforms. The goods yard contained a goods shed, coal wharves, a cattle loading dock and a 5-ton yard crane. The photograph is looking south towards Shrewsbury during the early 1960s; the main station building can be seen to the left, while the typical L&NWR gable-roofed signal cabin stands sentinel beside the level crossing.

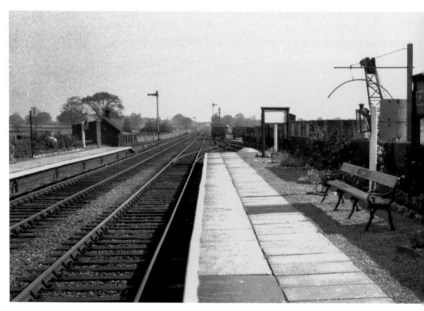

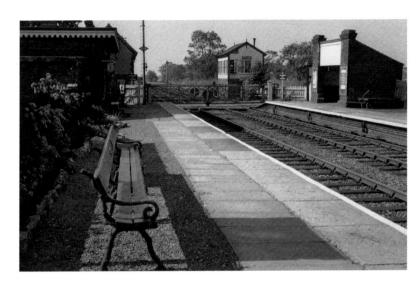

Prees

In architectural terms, Prees was an archetypal London & North Western station, its main station building, on the up side, being a typical North Western design. This red-brick structure incorporated a one-and-a-half-storey stationmaster's house, and an attached single-storey building that contained the booking office and waiting room facilities. The single-storey portion faced onto the platform and featured a central *loggia*, which was fully enclosed by a wood and glass screen to form a covered waiting area. The residential block sported a steeply pitched slate-covered roof, whereas the booking office portion had a flat roof. The left-hand view provides a glimpse of the waiting shelter on the down platform, while the colour photograph shows the main station building in 1973. This attractive Victorian building is now a private dwelling.

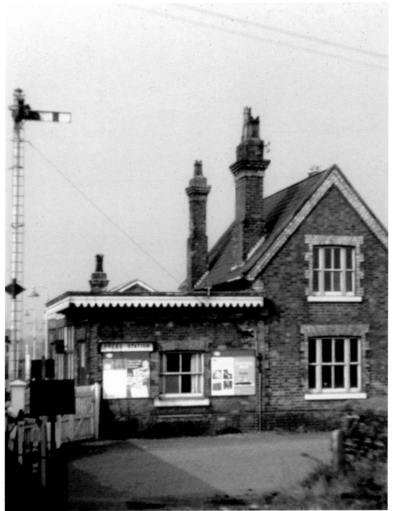

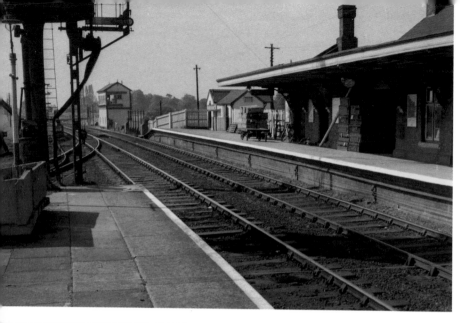

Whitchurch

Whitchurch, the next stop (113½ miles), was formerly a place of
considerable importance insofar as it was the junction for Cambrian
line services to Oswestry, Aberystwyth and Pwllheli, and also for
L&NWR services to Chester via Tattenhall Junction. The latter route
was opened on 1 October 1872, ostensibly to provide the North Western
company with a direct route to Chester and North Wales, although in
reality this 15-mile line was treated as a branch, with a service of about
seven trains each way during the LMS period.

The Oswestry line, which diverged south-westwards at the Shrewsbury
end of the station, was built by the Oswestry, Ellesmere & Whitchurch
Railway and ceremonially opened between Whitchurch and Ellesmere
on 20 April 1863, the inaugural train being hauled by the Oswestry &
Newtown Railway locomotives *Montgomery* and *Hero*. The new line was
opened for public traffic on 4 May 1863 and completed throughout to
Oswestry on 27 July 1864. By this time the Oswestry, Ellesmere
& Whitchurch Railway had been amalgamated with the Oswestry &
Newtown Railway and other companies to form the aptly named
Cambrian Railways.

The infrastructure provided at this country junction included an engine
shed, a turntable and other facilities for terminating services. Sadly, the
Whitchurch to Tattenhall Junction route was closed in September 1957,
while the Oswestry to Whitchurch line was closed with effect from
Monday 18 January 1964. Whitchurch station has nevertheless remained
in operation, albeit as an unstaffed halt.

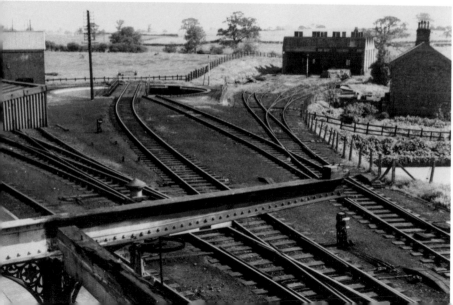

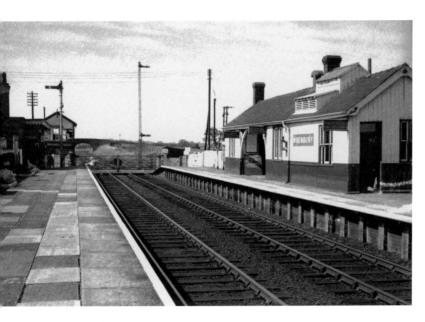

Left: **Wrenbury**

Curving onto a north-easterly alignment, the route continues to Wrenbury (118¼ miles) which, like other stations on the Shrewsbury & Crewe line, was opened on 1 September 1858. The main station building on the up side, which was similar to those at Yorton and Prees, was another red-brick, cottage-style structure incorporating residential accommodation for the stationmaster and his family. In addition to waiting room facilities, the 'house' portion had an upper floor within the attic, whereas the waiting room was of just one storey. The goods yard was able to deal with coal, livestock, furniture, vehicles and general merchandise traffic, while the 1938 Railway Clearing House *Handbook of Stations* also lists two private sidings, one of these being described as 'Poole's Siding', while the other was the 'Trufood Ltd Siding'.

Right: **Wrenbury**

A detailed view of the down side station building. This single-storey structure contained the booking office, together with a waiting room and toilets.

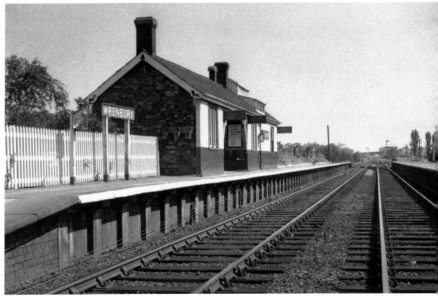

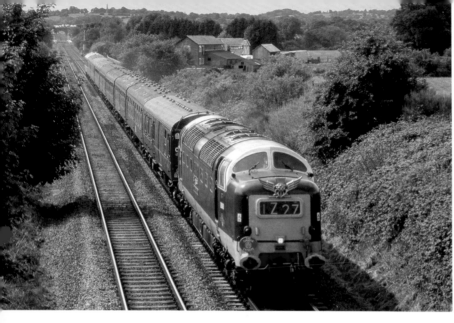

Wrenbury

Deltic class '55' locomotive No. D9000 *Royal Scots Grey* passes Wrenbury with the 10.18 a.m. Cardiff Central to Glasgow Central 'Tunnock Express', which conveyed athletes returning from the Special Olympics on 4 August 2001.

Nantwich

Nantwich, the last-but-one stopping place en route to Crewe, is 122¾ miles from Newport. The goods yard was closed in 1972, while the main station building, a rather grim Gothic-style structure, has now found a new role as an Indian restaurant. The photograph shows the now-demolished subsidiary building on the opposite platform, the level crossing and still-extant signal box being visible in the background. Resuming their journey, northbound workings pass the site of an abandoned station at Willaston, which was closed in 1954, and having joined the West Coast Main Line, trains finally reach Crewe. Here, some 127¼ miles from Newport, journeys over the North & West route come to an end amid the noise and bustle of a great main line station, although some longer-distance services have latterly continued north-eastwards to Manchester Piccadilly.

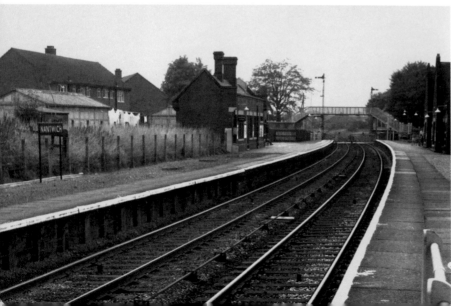